IMAGES
of Aviation

AVIATION IN
SAN DIEGO

IMAGES
of Aviation

AVIATION IN
SAN DIEGO

Katrina Pescador and Alan Renga
San Diego Air and Space Museum

ARCADIA
PUBLISHING

Published by Arcadia Publishing
Charleston, South Carolina

Printed in the United States of America

Library of Congress Catalog Card Number: 2007921319

For all general information contact Arcadia Publishing at:
Telephone 843-853-2070
Fax 843-853-0044
E-mail sales@arcadiapublishing.com
For customer service and orders:
Toll-Free 1-888-313-2665

Visit us on the Internet at www.arcadiapublishing.com

To all the brave pilots of yesterday and today

CONTENTS

ACKNOWLEDGMENTS

We would like to thank the staff and volunteers who helped with the research of this publication. In particular we extend recognition to Pam Gay, Nick Galatis, Ray Wagner, Dennis Stewart, John Lull, Myles Todd, and Bill Vance. Special recognition is given to Linda Sprekelmeyer, who was an invaluable help in editing this work. All images used within this book are from the archives of the San Diego Air and Space Museum.

INTRODUCTION

San Diego, with its ideal climate and location, lures millions of visitors to this region annually. It is these conditions that have also attracted aviation enthusiasts to the area for over a century. San Diego's climate, which provided for optimal year-round flying conditions, drew many individuals interested in aircraft experimentation, flight instruction, and the aircraft industry. As early as the late 1800s, John Montgomery was performing glider experiments. Charles Hamilton and Waldo Waterman also experimented with powered flights in San Diego.

The first San Diego Air Meet was held on Coronado Island in 1910, drawing aviation enthusiasts from all over the United States. Many of these enthusiasts never forgot the ideal weather conditions and perfect location, influencing them to relocate and continue their flying careers here.

Glenn Curtiss brought his airplane to San Diego in December 1910. From his hometown of Hammondsport, New York, Curtiss came to escape the winter weather and take advantage of the obvious climatic benefits of Southern California.

Curtiss opened his Aviation School on North Island and started training pilots, including Theodore G. Ellyson, the U.S. Navy's first aviator. Shortly thereafter, Curtiss was training army aviators on North Island also, establishing an early tradition in San Diego of having a large military presence, housing land, sea, and air bases. Major military ships can be seen in the background of many of the photographs contained in this book. This large military presence is still very much alive.

Civilian pilots also flocked to San Diego in the early 1900s, thrilling locals with their aerial exploits. Lincoln Beachey, known for his upside down stunts, was among the most famous to perform here. Soon, however, most of San Diego's aviation resources focused on helping the United States win World War I.

After the war, aviation in San Diego exploded with daring young aviators giving death-defying performances. In 1922, T. Claude Ryan opened up a flying service here, which led to the manufacture of some of the most creative designs in aviation history. One of the most famous of these designs was the *Spirit of St. Louis*, used by Charles Lindbergh on his nonstop solo flight from New York to Paris in May 1927. When San Diego's new municipal airport was opened, it was named Lindbergh Field, and San Diego became known as the "Air Capital of the West."

The greatest impact on San Diego aviation was made by Reuben H. Fleet, president of Consolidated Aircraft Corporation in Buffalo, New York. New York's bad weather frustrated Fleet, often delaying flight tests of the big flying boats he was building for the U.S. Navy. Aware of the ideal weather conditions in San Diego, Fleet decided to move his entire operation. A large Consolidated Aircraft Corporation manufacturing plant opened at Lindbergh Field in 1935. This plant, along with neighboring Ryan Aeronautical, would produce thousands of aircraft during World War II, contributing to America's victory. The growth of San Diego's aviation industry during World War II contributed to the expansion of the area, both in terms of economics and increased population.

This growth continued even after World War II, as local aerospace companies continued to produce innovative military and commercial aircraft. San Diego companies played a vital role in the space race also; equipment produced in the area assisted in putting a man on the moon.

In the second half of the 20th century, San Diego–based Pacific Southwest Airlines (PSA) would leave its mark on commercial air travel, providing the friendliest service in the skies. As a new century dawned, local military bases continued to be among the most important in America.

An incredible amount of significant aviation-related events have occurred in San Diego over the last century, making the selection of photographs to use in this book a difficult task. The San Diego Air and Space Museum's library and archives houses over a million images related to San Diego aviation, one of the largest in the United States. Images from this impressive collection were used to compile this book. Because of space constraints, not all events, people, and aircraft concerning San Diego have been included. The authors selected photographs believed to have the most significance or that could stir certain memories or emotions. Hopefully the selection used is enjoyed. This collection of photographs exemplifies why San Diego truly has been, and will continue to be, such an important part of aviation history.

One

THE EARLY YEARS

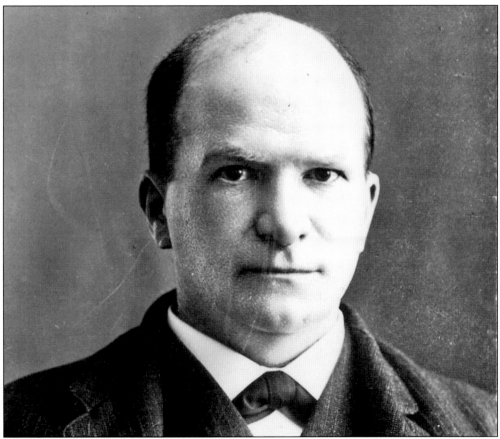

Even before the Wright brothers made their first powered flight, John Montgomery was testing his theories of aerodynamics in San Diego, California. Although he is not as well known as the Wright brothers, Montgomery made significant contributions to the knowledge of flight and by doing so put San Diego on the map as one of the first centers of flying. Both innovative and daring, Montgomery embodies San Diego's early days of flight, qualities that cost some aviation dreamers their lives. In 1883, John J. Montgomery constructed a monoplane glider with curved wing surfaces, in which he made a glide of some considerable length from Otay Mesa, near San Diego. The validity of this claim is disputed as particulars of this flight remain somewhat obscure, and no written record of the event has survived. It is known, however, that Montgomery made subsequent successful gilder flights in Northern California.

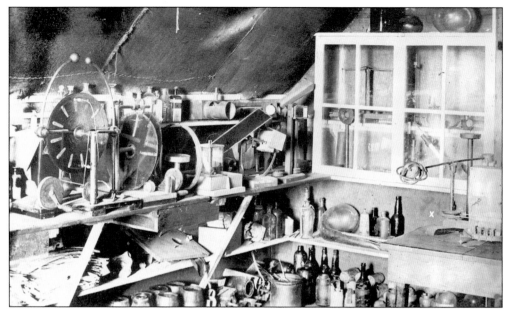

This rare photograph gives a look inside John Montgomery's laboratory in San Diego County as it appeared in 1885. Many of the instruments and contraptions pictured here were used to test balance, and Montgomery applied his findings in the construction of his flying machines.

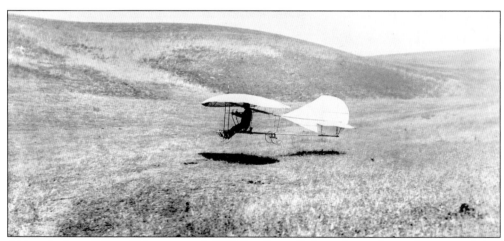

Although the validity of Montgomery's 1883 San Diego flight is disputed, it is documented that he completed later flights and contributed greatly to the knowledge of aviation. Here he is seen in his Evergreen machine in 1911. Montgomery died in this glider shortly after this photograph was taken.

Octave Chanute visited San Diego in 1894 in an unsuccessful attempt to meet with John Montgomery. The trip was not wasted, however, as San Diego's excellent weather conditions remained in Chanute's memory. A few years later, when the Wright brothers asked Chanute to recommend a better place than Dayton, Ohio, for their experiments, he recommended Kitty Hawk, North Carolina, and San Diego, California, as two ideal locations.

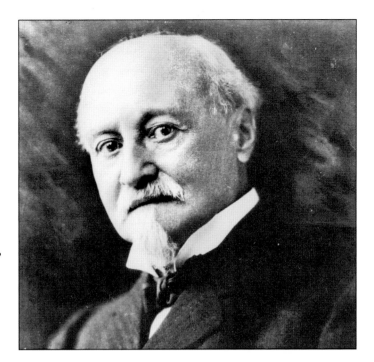

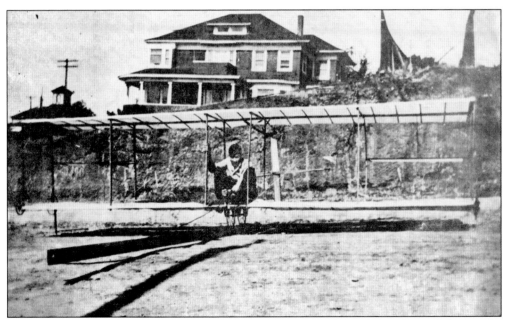

Waldo Waterman, a local high school boy who was excited about the exploits of the Wright brothers, decided to build a glider in 1909. Over the next few months, Waterman would have many successful flights. He continued to design and build numerous innovative airplanes. Here the young Waldo is seen in his glider.

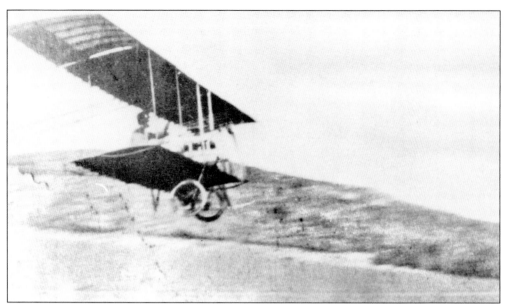

Donald Gordon's original experiments were with gilders, and he claims to have flown a powered glider in June 1909 near El Cajon, California, making him the first in San Diego to make a powered flight. Unfortunately there are no records or witnesses to this event, and the airplane was destroyed. What is known with certainty is that Gordon eventually flew this biplane in April 1910. Gordon went on to design other aircraft, including an enclosed cockpit monoplane.

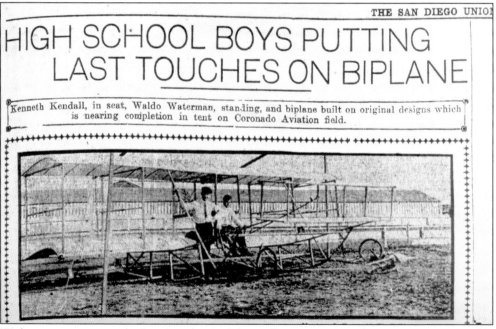

HIGH SCHOOL BOYS PUTTING LAST TOUCHES ON BIPLANE

Kenneth Kendall, in seat, Waldo Waterman, standing, and biplane built on original designs which is nearing completion in tent on Coronado Aviation field.

Wishing to compete in the Los Angeles Air Meet at Dominquez Ranch in January 1910, Waldo Waterman and Kenneth Kendall worked diligently to build an airplane but were unable to complete it in time. When they finally finished their plane, a flight attempt left Waldo with two broken ankles. This Waterman/Kendall aircraft was the second documented airplane to successfully fly in San Diego.

Frenchman Louis Paulhan was awarded the 1910 San Diego trophy for breaking the altitude record of 4,140 feet at the Dominguez Air Meet; in addition, the city of San Diego offered him $5,000 to fly from San Francisco to San Diego for the Pan American Exposition. Paulhan was unable to comply, so Curtiss pilot Charles Hamilton accepted the invitation to fly in the two-day air show that began in San Diego on January 23, 1910.

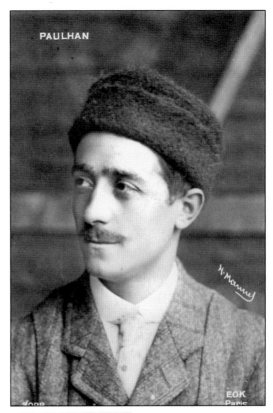

Charles Walsh designed and built a powered airplane that he attempted to fly at the first San Diego Air Meet on January 23, 1910, in Coronado, California. If successful, this would have been the first verified powered flight in San Diego. Unfortunately the attempt ended in disaster when his plane was destroyed after it struck a fence. Walsh died two years later while flying in an aerial demonstration.

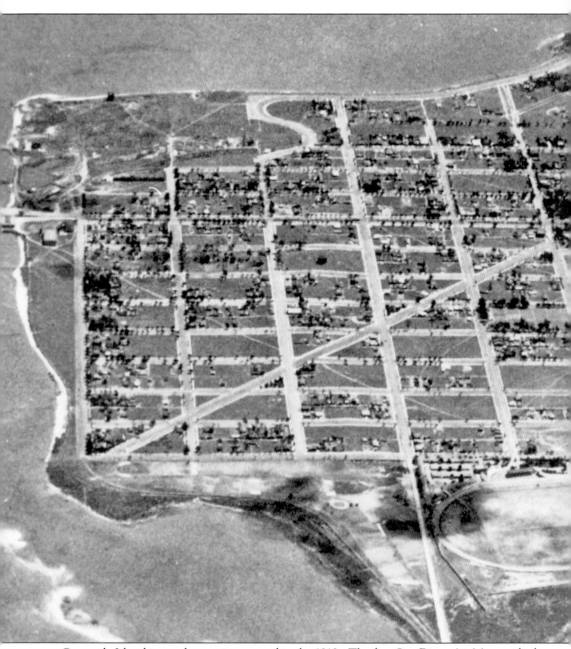

Coronado Island is seen here as it appeared in the 1910s. The first San Diego Air Meet took place on the polo grounds located on the lower portion of the island. Winfield Hogaboom, publicity director for the Panama-California International Exposition, and D. C. Collier, chairman of the chamber of commerce aviation committee, coordinated this first San Diego Air Meet that took

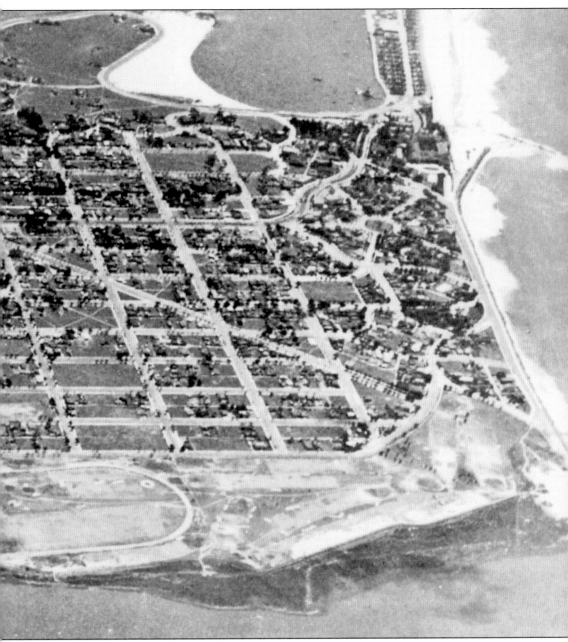

place on January 23, 1910. The water inlet, known as Spanish Bight, is where the famous aviator, Glenn Curtiss, completed many of his early flights. The bight was eventually filled in with dredge from San Diego Bay during World War II.

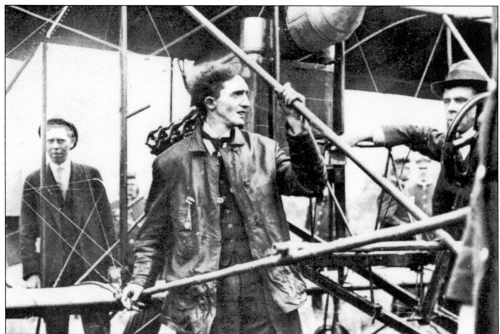

After Walsh's failed powered flight attempt, Charles Hamilton was successful in making the first verified powered flight in San Diego County at the San Diego Air Meet in a Curtiss Pusher. Hamilton continued flying that day, making six flights and thrilling spectators as he jauntily dangled a cigar from his lips.

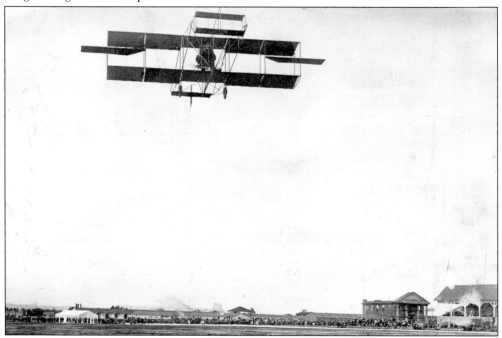

Continuing to add to his impressive list of first-flight successes, the next day Charles Hamilton became the first aviator to cross the United States-Mexico border in an airplane. Hamilton died at the young age of 28, ironically due to a lung hemorrhage and not as the result of his aerial exploits.

After the first San Diego Air Meet was held on Coronado Island, aviation fever hit San Diego, and a few daring locals took to the air. Among them was Bernard Roehrig, who flew his biplane, powered by a six-cylinder automobile engine, from Imperial Beach during the summer of 1910. Undeterred by his failed attempt to make the first powered flight in San Diego, Charles Walsh also flew from Imperial Beach during this time.

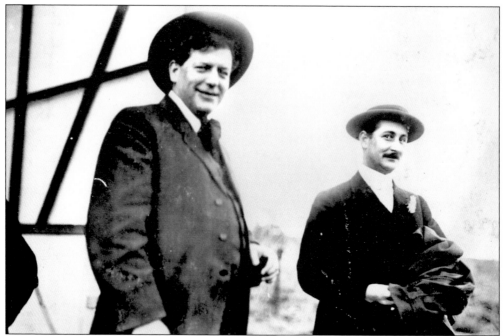

In early 1911, Harry Harkness (right), a wealthy New York businessman, formed the Aero Club of San Diego and sponsored an aviation venture with famed aviator Glenn Curtiss. Together they signed a three-year lease agreement with the Coronado Beach Company for the use of North Island. Pictured on the left is local aviation enthusiast, D. C. Collier.

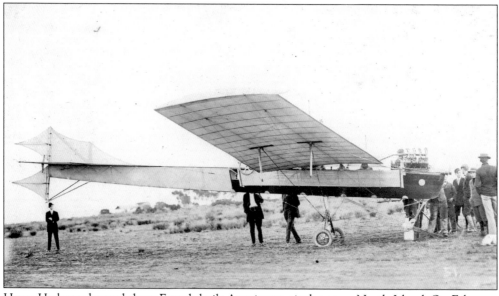

Harry Harkness housed three French-built Antoinette airplanes on North Island. On February 7, 1911, Harkness delivered a message from Major McManus at Fort Rosecrans to Lieutenant Ruhlen at an army camp by the United States-Mexico border, accomplishing an aviation first. The practice of using aircraft to deliver messages from a commanding officer to a subordinate in the field had just begun. This unique monoplane was a rare design in aviation when most airframes had two wings.

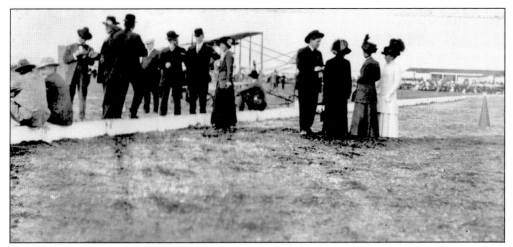

The second San Diego Air Meet was held at the Coronado Country Club polo grounds on January 28 and 29, 1911. Glenn Curtiss, Eugene Ely, and Hugh Robinson were just three of the many well-known flyers who entertained spectators during this event. Seen here is the air meet organizer, D. C. Collier, enjoying the sights with some ladies on the last day of the show.

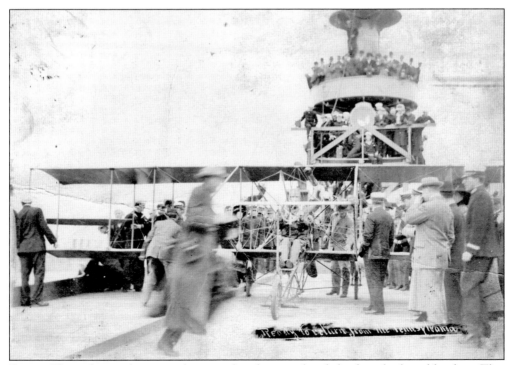

Eugene Ely made naval aviation history when he completed the first shipboard landing. This historic accomplishment took place on the USS *Pennsylvania* while it was moored in San Francisco Bay. Ely was one of the headliners at the 1911 San Diego Air Meet and a prior Curtiss student.

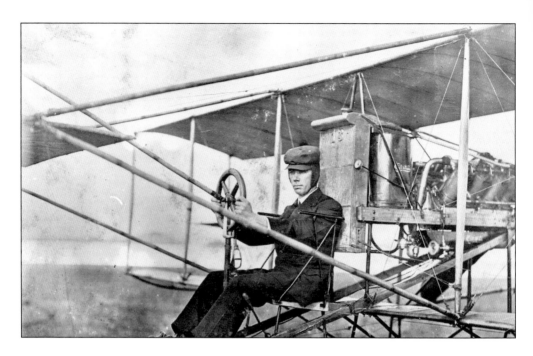

Hugh Robinson thrilled spectators at the 1911 San Diego Air Meet on Coronado. One of the highlights of this meet was an exciting race between Eugene Ely and Hugh Robinson, which drew quite a crowd. Although the outcome was hotly contested, it appears that Robinson was the winner. This air meet created a great deal of local excitement about aviation. As a result, the Curtiss Aviation School, where Robinson worked as a flight instructor, attracted many new students.

Charles H. Toliver envisioned commercial travel and designed an airship that could carry 40 passengers from San Diego to Los Angeles and San Francisco. Establishing the Toliver Aerial Navigation Company of San Diego, he began work on an airship that could fly in all conditions. The dirigible was 250 feet long, 40 feet in diameter, and was propelled by four 18-horsepower engines driving six propellers, one on each end of the envelope and two on each side. Costing $60,000 per airship, Toliver sold stock in his company in order to finance this endeavor.

On November 11, 1911, thousands arrived at the airship yard to see the dirigible's first flight, but the ship never got off the ground. Toliver's airship is seen here in its construction pit, located in a canyon at Thirty-first Street between B and C Streets.

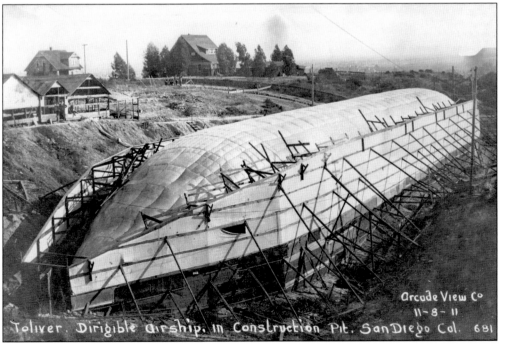

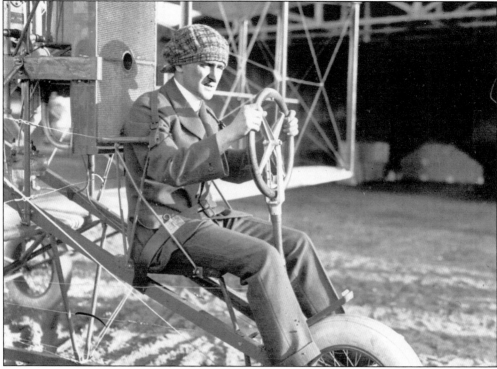

On November 15, 1912, Lincoln Beachey, seen here in 1912, brought his pusher airplane to San Diego. Beachey boasted he would fly the first loop-the-loop in the United States. This particular stunt had already been successfully performed in Europe. On Thanksgiving Day 1912, he completed three loops and earned a $2,000 prize for each one.

Georgia "Tiny" Broadwick, dubbed the "Little Queen of the Clouds," started parachuting from balloons in 1908 when she was only 15 years old. In 1913, she became the first woman to jump from an airplane. The following year, Broadwick performed the first parachute jump in San Diego, as seen here, with famous aviator Glenn Martin in his "pusher" aircraft. Broadwick performed several times over Balboa Park during the California-Panama International Exposition.

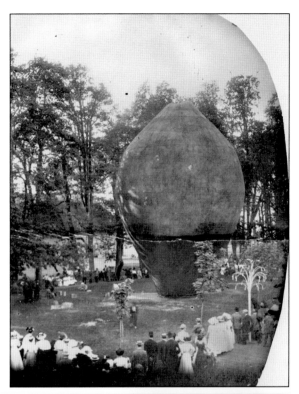

To celebrate the opening of the Panama Canal, San Diego held the California Pacific International Exposition in 1915. Katherine Stinson, the fourth woman in the United States to receive her pilot's license, was asked to perform. On November 20, she looped-the-loop over the exposition located in Balboa Park while dropping flowers on thrilled onlookers below.

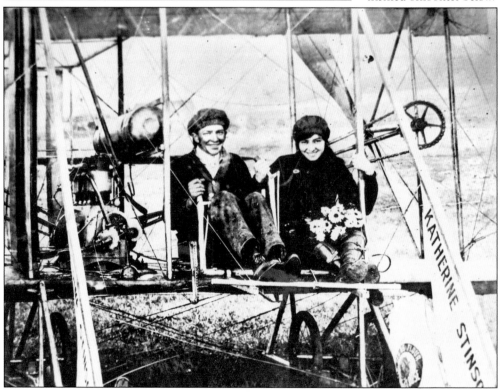

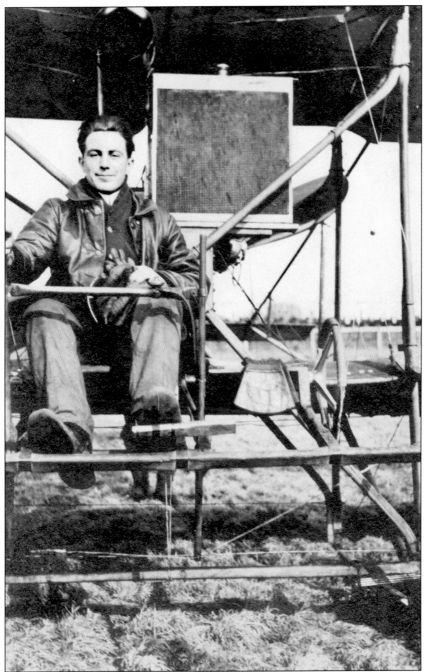

Tony Jannus sits at the controls of one of his airplanes. Operating a Benoist flying boat, Tony Jannus, his brother Roger, and J. D. Smith started a flying business at the foot of Market Street on January 4, 1915. Prior to this, Tony had operated a similar service in Tampa, Florida, which many believe was the world's first regularly scheduled passenger service. While in San Diego, Roger received his seaplane pilot's license no. 26 from the Aero Club of America. On February 19, Smith crashed the flying boat into San Diego Bay. The aircraft was unsalvageable, resulting in their return back East.

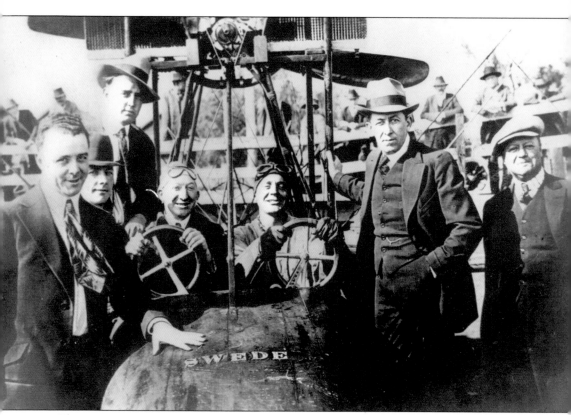

That same year, Orval "Swede" Meyerhoffer started up an aerial ferrying service on Market Street. After six months, Swede had carried over 2,000 passengers on flights. As a memento, passengers could buy a picture of themselves in the cockpit with the pilot. Later the San Diego Fire Department employed Meyerhoffer to pilot a flying fire truck, which was called "Aerial Truck No. 1." However, he never fought a real fire.

Two

GLENN CURTISS

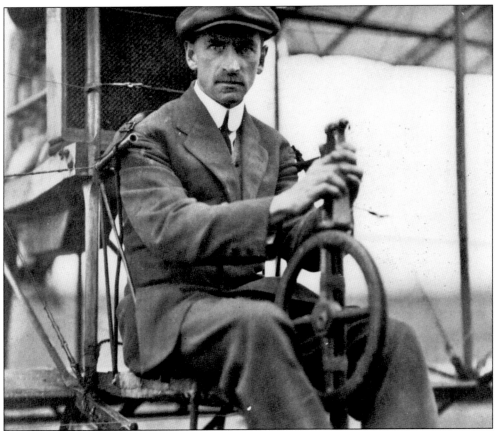

Glenn Curtiss, who was already a famous airplane builder and pilot, first learned of San Diego while participating in the 1910 Air Meet in Los Angeles. At that time, Curtiss had been conducting most of his aviation experiments in New York, but the winters there made it impossible to fly year-round. Curtiss was immediately attracted to the ideal weather and isolation of San Diego's North Island, and the San Diego chapter of the Aero Club of America arranged with the Coronado Beach Company to permit Curtiss to use San Diego's North Island for a three-year period at no cost. Curtiss signed a lease for use of this land and set up his famed Curtiss Aviation School. Several of Curtiss's flight school graduates went on to set records and gain world recognition as aviators. While here, he also conducted various aerial experiments, building and refining his aircraft designs. This image of Glenn Curtiss shows him sitting at the controls of one of his early aircraft wearing his signature cap.

December 23, 1910.

From: Acting Secretary of the Navy.
To: Lieutenant
 Theodore G. Ellyson, U.S.N.,
 Newport News S.B. and D.D. Co.,
 Newport News, Va.
 (Inspector of Machinery)

 SUBJECT: Detached duty Newport News S.B. & D.D.
Co., Newport News, Va., to duty instruction in aviation
Los Angeles, Cal.

 You are hereby detached from duty at the
Newport News S.B. & D.D. Co., Newport News, Va., and
from such other duty as may have been assigned you;
will proceed to Los Angeles, Cal., and confer with
Mr. Glenn H. Curtis at his aerodrome at that place
for instruction in the art of aviation, and report
by letter to the Commandant of the Navy Yard, Mare
Island, Cal., for this duty.

 You will report your progress at the end of
each month, and report any circumstance which in your
judgment you may deem of interest to the Navy Depart-
ment in regard to aviation; you will keep a journal
of practical observations such as may be of assistance
in the training of the Navy personnel in aviation.

 When in your opinion and that of Mr. Curtis you
have qualified in practical aviation you will so report
to the Navy Department.

 This employment on shore duty is required by
the public interests.

In an attempt to interest the U.S. Navy in aviation, Glenn Curtiss wrote to the secretary of the navy on November 14, 1910, offering to teach one naval officer to fly free of charge. On December 23, 1910, the navy ordered a submarine officer, Lt. Theodore G. "Spuds" Ellyson, to report to the Curtiss Aviation School on North Island.

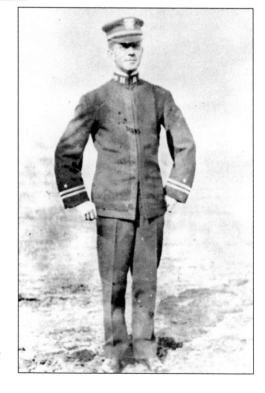

Lt. Theodore G. "Spuds" Ellyson looks sharp in his navy uniform. Evident in this photograph is the self-confidence that was necessary in the early days of aviation. Being a pilot during this period, arguably, was the most dangerous job in the world, and very few early aviators lived to see old age.

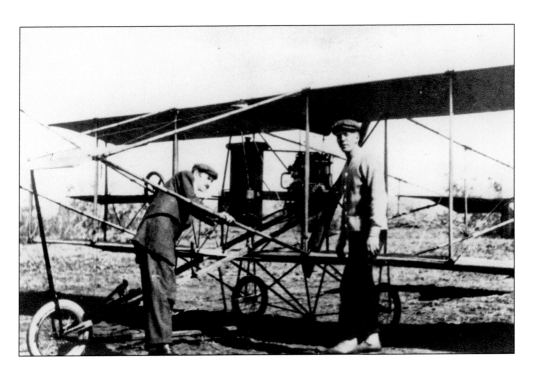

Lieutenant Ellyson arrived in California in January 1911 to go through flight training at the Curtiss Aviation School on North Island. As seen here, Ellyson is receiving one of his first flying lessons from Glenn Curtiss in February 1911. The aircraft is a single-surface, low-powered "grass cutter." This aircraft was safe for giving flight lessons, because it could not fly very high. Ellyson subsequently became the navy's first aviator.

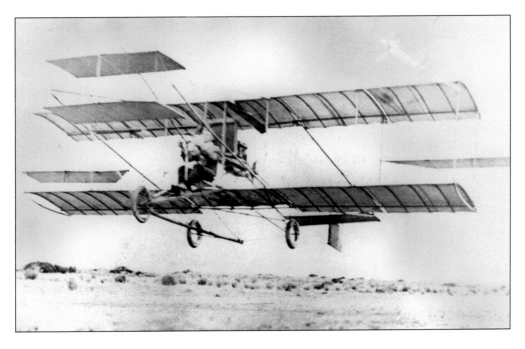

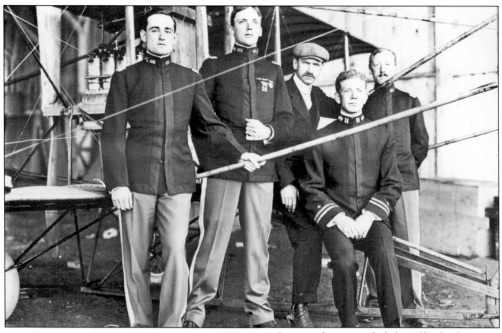

Curtiss also extended the offer for free flight instruction at Curtiss Aviation School to the U.S. Army, and it was accepted. As a result, the United States' first Military Aviation School opened on North Island on January 17, 1911. The first military flight class, pictured here from left to right, includes Lt. John C. Walker, army; Capt. Paul W. Beck, army; Glenn Curtiss; Lt. Theodore Ellyson, navy; and Lt. G. E. Kelly, army.

Just three months after completing his flight training at the Curtiss Aviation School, Lt. G. E. Kelly died in a crash at San Antonio, Texas. Kelly Air Force Base, located in San Antonio, was named after him.

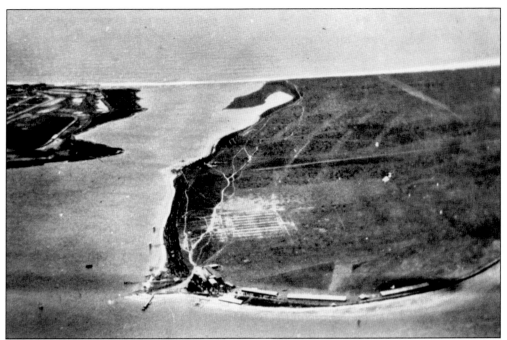

This is a view of North Island as it appears a few years after Curtiss's arrival. North Island lies across San Diego Bay, 1 mile from the city. It measures approximately 4 miles long and 2 miles wide. North Island is joined with Coronado (on the left) by a narrow sand spit on the south side, which is often washed over by the high tides. The islands are usually separated by a strip of shallow water called the "Spanish Bight," where Curtiss conducted many of his early flying experiments.

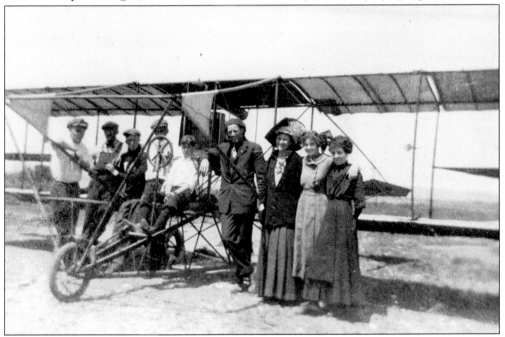

The first Curtiss biplane arrived at North Island in 1911. Many excited locals turned out to get a look at this newfangled contraption, eager to have their picture taken with the airplane.

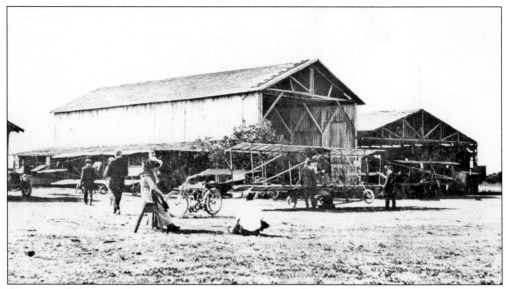

Curtiss used these two large hangars on North Island as his workshops. This is the location he chose to design and build most of his aircraft. The motorcycle visible in the foreground probably belonged to Curtiss. Prior to his involvement in aviation, Curtiss was a renowned builder and racer of motorcycles.

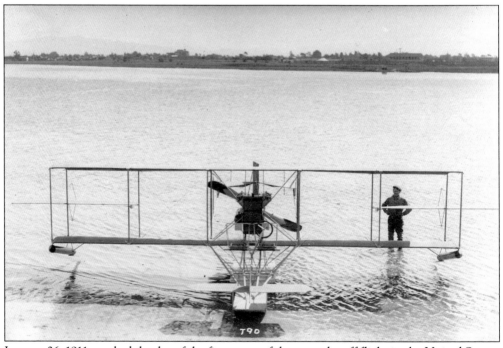

January 26, 1911, marked the day of the first successful water take-off flight in the United States. This historic flight was accomplished by Glenn Curtiss at the Spanish Bight. The aircraft used was one of his modified designs.

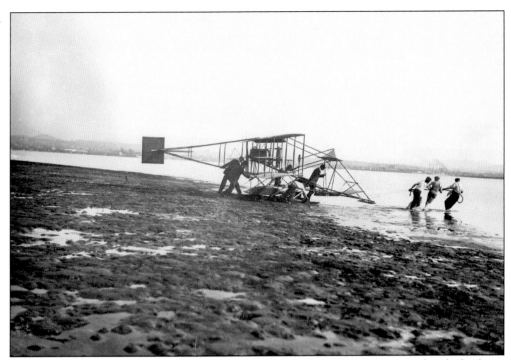

The first single-pontoon plane was built by R. H. Baker of San Diego. Impressed with this basic design concept, Curtiss included it in most of his designs for the Curtiss hydroaeroplanes.

On February 17, 1911, Curtiss took off in his hydroaeroplane from San Diego Bay and landed alongside the navy cruiser USS *Pennsylvania*. His aircraft was lifted onboard by a standard boat crane and placed on the deck. A month earlier, one of Curtiss's students, Eugene Ely, had successfully landed on the *Pennsylvania* while it was moored in San Francisco Bay. Both flights demonstrated the future importance of aircraft to naval operations.

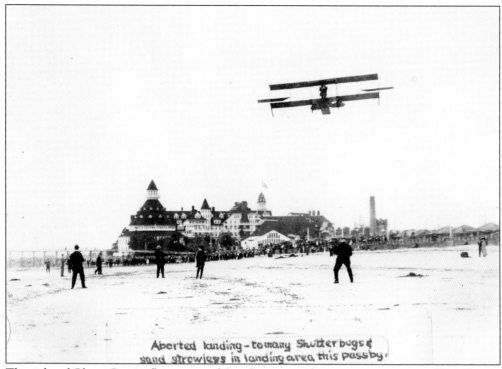

Aborted landing - to many shutterbugs & sand strowlers in landing area this pass by.

The sight of Glenn Curtiss flying around San Diego soon became very common. Here Curtiss soars above the Coronado Hotel in his Triad in February 1911. The beach was so crowded with "shutterbugs and sand strollers" in the landing areas that Curtiss had to make several attempts before he was able to land safely.

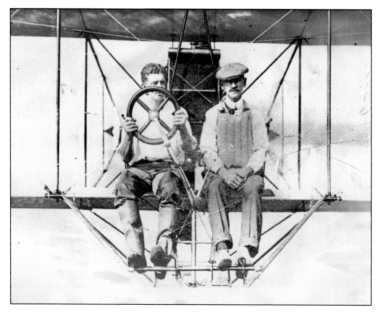

As a safety measure for use at his flying school, Curtiss developed throw-over controls in his aircraft, allowing the instructor and student to take turns flying. Here Ellyson holds the controls, while Curtiss appears to be the nervous passenger.

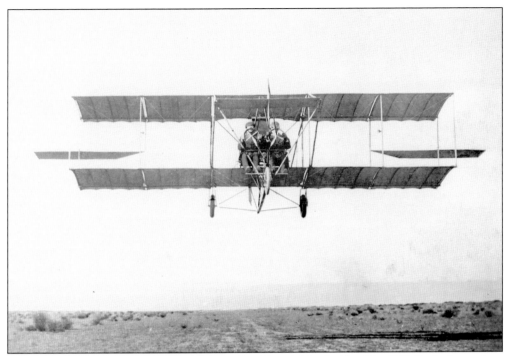

Pictured here is a Curtiss trainer airplane at San Diego's North Island in 1911. Both the student and the instructor have their hands on the control wheel. Obviously a great deal of cooperation was required to keep the plane from crashing.

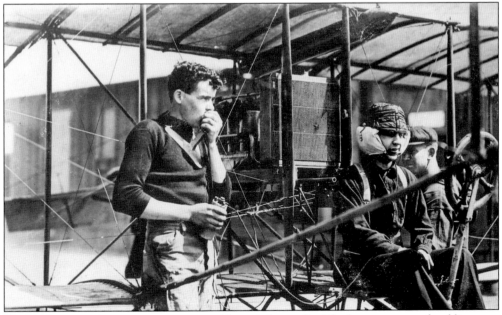

Two students are shown experimenting with a wireless radio. The large amount of padding over the pilot's headset was required to drown out the airplanes' engine noise. Glenn Curtiss and Howard Morin were the first to use radios in an airplane.

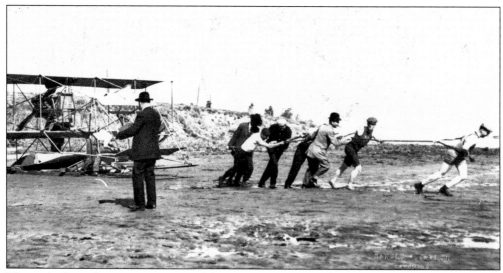

The early days of aviation were very labor intensive. Notice how many students were needed to free a Curtiss airplane that had been stranded on the beach when the tide went out. It was situations such as this that prompted Curtiss to put wheels on his hydroaeroplanes.

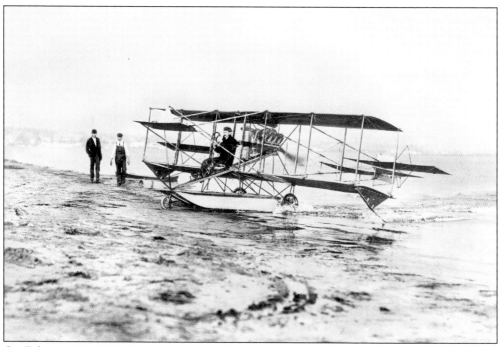

On February 25, 1911, Curtiss made the first successful amphibious flight at North Island. Curtiss modified his hydroaeroplane with retractable wheels under the lower wings, making it the first land-sea airplane, known as the Triad. Built later, the A-1 and A-2 hydroaeroplanes were modeled after this Triad design. By the autumn of 1911, Curtiss was advertising seaplanes on the open market.

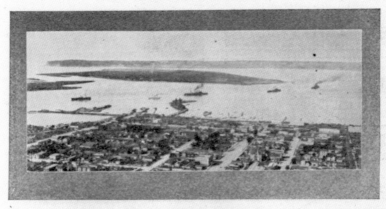
In addition to training military pilots, Curtiss also trained civilians at his flight school on North Island. Many of these graduates went on to become famous aviators. This early advertisement for the Curtiss Aviation School was placed in the Aero America's *Aviation Weekly*, Vol. 3 No. 4, dated October 28, 1911. The Curtiss Aviation School graduated more pilots than any other school in 1912, becoming the largest flying school in the United States.

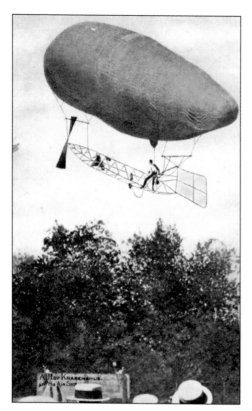

Balloonist Lincoln Beachey joined the class of 1911 at the Curtiss Aviation School. As a student, Beachey wrecked three planes and Curtiss didn't think he would ever make it as a pilot. Beachey once told a friend, "Flying did not come readily to me at first. But when it did, it arrived big—all of a sudden." Beachey went on to become one of the most famous acrobatic pilots, performing loop-the-loops and other daredevil stunts. Glenn Curtiss called him "the greatest artist in the aeroplane." Beachey died at the age of 28 when structural failure caused him to plunge into San Francisco Bay during a 1915 show.

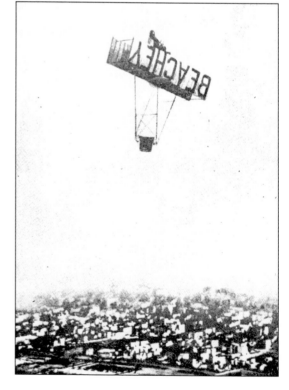

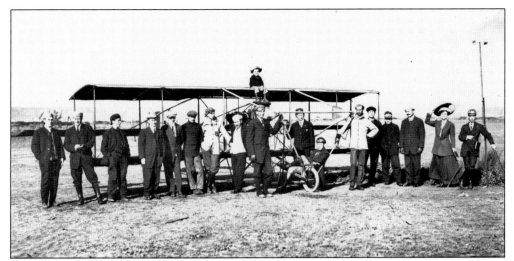

Curtiss attracted a wide variety of students, including a husband-and-wife team. In 1911, William Atwater, and his wife, Lillian, came to North Island to take up the sport of flying. The couple purchased their own hydroaeroplane from Curtiss and traveled to China and Japan. Atwater entered an aviation meet in Los Angeles and set an American speed record of 73.08 miles per hour. Lillian never received her pilot's license but did fly. She can be seen on the right.

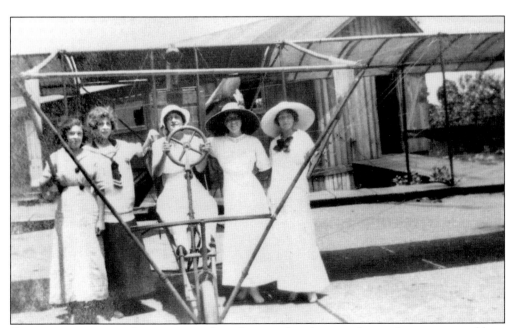

Curtiss was not one to discriminate in his selection of students, and several women were able to take flying lessons from the Curtiss Aviation School. Five unidentified women pose here with a Curtiss Pusher in June 1912.

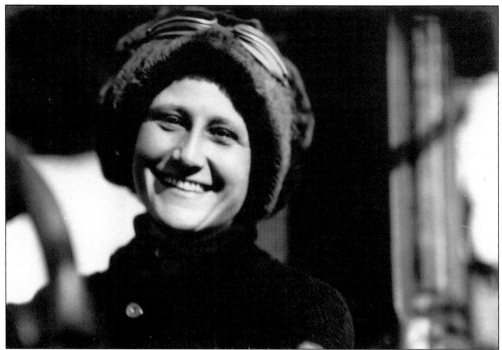

Julia Clark fell in love with flying at the Chicago Air Meet in 1911. Clark relocated to San Diego and became the first female student at the Curtiss Aviation School. Dying in a plane crash in 1912, Clark was able to fly for only a few short months prior to this fatal accident.

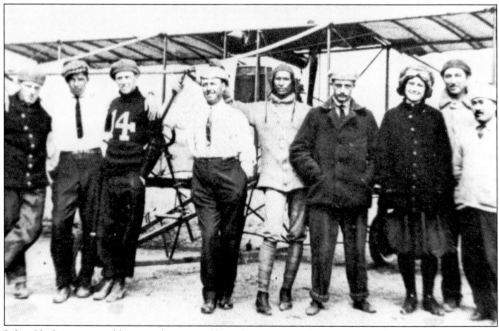

Julia Clark is pictured here with some of her classmates at the Curtiss Aviation School in 1912. Included in the photograph are Floyd Barlow, John G. Kaminski, Roy B. Russell, Mohan M. Singh, John Lansing Callan, Julia Clark, M. Dunlap, and Kono Takeshi.

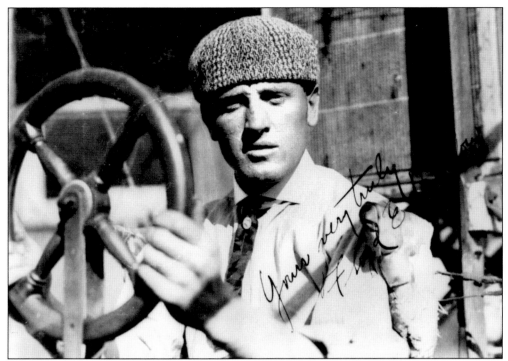

"Early Bird" Floyd Barlow was a student at the Curtiss Aviation School in North Island around 1912. A very amusing incident occurred at the school on June 12, 1912, when Barlow swung the propeller on his Curtiss trainer to start the engine. He had left the throttle all the way open and the engine easily caught. Barlow helplessly watched as his airplane sped away from him. The plane even managed to lift up into the air for a few seconds before crashing to the ground destroyed. Luckily no one was injured.

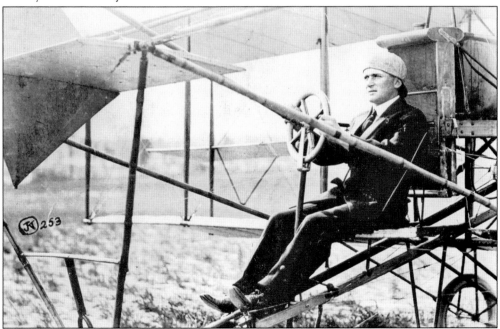

The first group of Japanese aviators were trained at the Curtiss Aviation School. Among these students was Lt. C. Yamada, who later became famous during World War II as the head of Japan's Naval Aviation. Pictured here is an unidentified Japanese student bedecked in all of the fashionable flying attire that protected the pilot from both injury and the elements.

General Nagaya, another Japanese student taking flying lessons at the Curtiss Aviation School, sits at the ready in May 1913. Evidently he borrowed one of Glen Curtiss's signature caps for good luck.

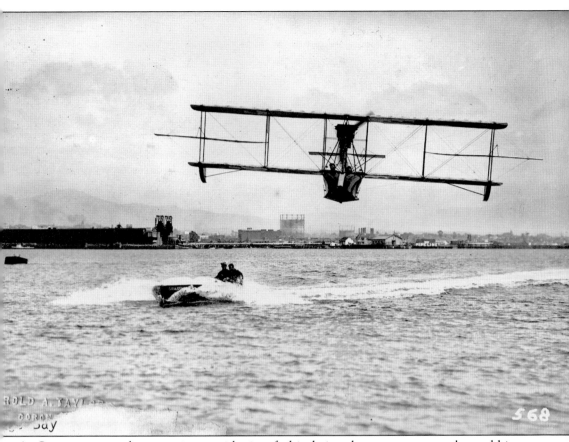

As Curtiss continued to experiment with aircraft, his designs became more complex and his aircraft began to include safety features intended to protect the pilot and passengers. Notice the enclosed cockpit seen here in this modified Curtiss hydroaeroplane. The plane is being followed by a chase boat on San Diego Bay. After Curtiss, the bay would be the home of many flying boats, from the well-known Consolidated PBY to the more obscure Convair Sea Dart. Even the famous China Clipper boats would visit the San Diego Bay.

After Lt. Theodore G. "Spuds" Ellyson completed his flight training, the navy instructed him to set up a Navy Aviation Camp alongside the Curtiss Aviation School on North Island. A temporary navy camp, consisting of tents for personnel and aircraft and known as "Camp Trouble," was set up on the northeast side of the island. The navy occupied this camp from January 1912 until May 2, 1912. When the navy attachment was transferred to Annapolis, the army took up residence. The navy returned to North Island five years later. Photographed here are Ellyson and Witmer, seen standing outside their tents.

Three

NORTH ISLAND

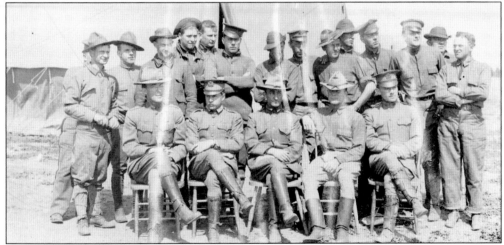

After the documented successes of Glenn Curtiss at North Island, it was logical that the armed forces would select this location as a base for their fledging military aviation group, and Glenn Curtiss invited them to share North Island with him. When the first detachment of army aviators arrived, there was no way of knowing they would be the first of many thousands of troops assigned here. In November 1912, a sergeant arrived with eight enlisted men in his charge. Two weeks later, the detachment commander, Lt. Harold Geiger, arrived. It wasn't long before additional personnel showed up, building a camp and clearing a runway. This area was soon designated the Signal Corps Aviation School. Pictured here are Lieutenant Geiger (seated center) and some of the other officers and enlisted men. To this very day, North Island is known around the world as one of the foremost military aviation installations in the world.

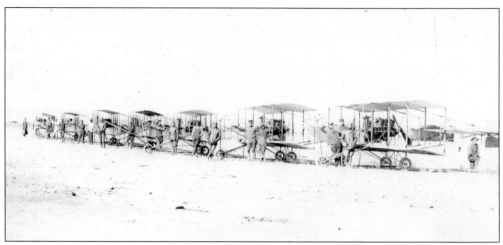

Curtiss's decision to allow the army to share North Island was a smart financial move. Since they were so close to him, it was easy for the army to view and purchase several of his aircraft. Members of the U.S. Army Signal Corps School are seen as they proudly line up by their Curtiss Pushers.

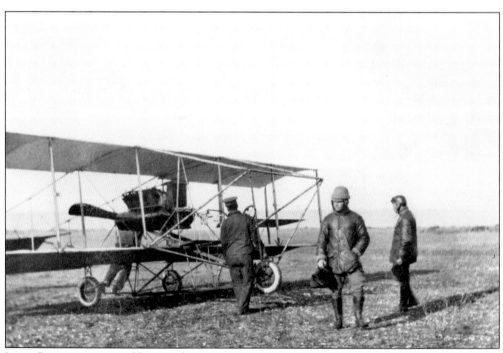

Lewis Bereton is pictured here with a Curtiss Pusher. This type of aircraft was used most often by the Signal Corps Aviation School during its early days. Bereton is one of the first pilots at the Signal Corps Aviation School in 1913.

Many of the pilots at the Signal Corps school flew pushers, an aircraft type that had the engine positioned behind the pilot. During a crash, the power plant would often work itself loose and squash the pilot, making it an extremely dangerous plane to fly. As a result, several early pilots lost their lives at North Island. Lt. Eric Ellington, pictured here, and his student Hugh Kelly were both victims of this design, killed instantly on November 24, 1913, when their Wright C aircraft crashed.

Another Signal Corps pilot who lost his life at North Island was Henry Post. After reaching 12,140 feet and breaking his own altitude record, Post lost control of the Wright C hydroaeroplane he was flying. At 1,000 feet, the airplane went vertical, and Post was thrown out. He died upon impact with the water.

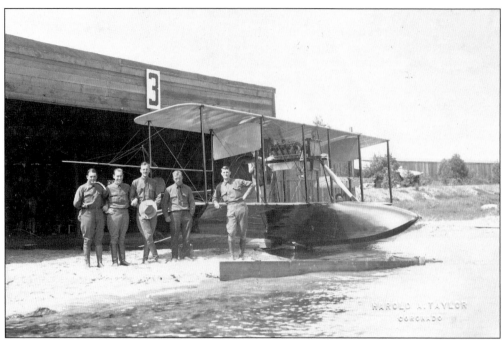

Army officers stand proudly beside a Curtiss F-boat at North Island. This airplane was sturdier than the earlier pusher types. Some pilots preferred the F-boat, believing it provided them a better chance of survival if something went wrong.

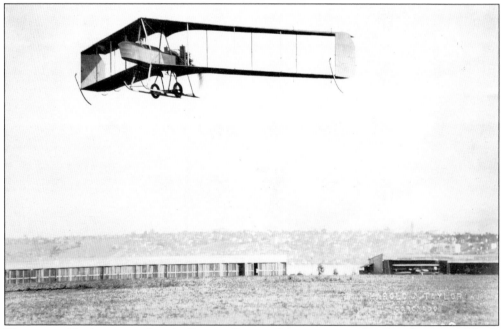

This unusual-looking aircraft is the Burgess-Dunne, Salmson-powered pusher flying over North Island around 1914. The innovative V-design foreshadows some of the flying wing designs that would revolutionize the aerospace industry. Later aircraft designs that incorporated this unique flying wing concept include the Northrop Flying Wing and the B-2 Stealth Bomber.

In September 1914, the First Aero Squadron was established at North Island. Consisting of 16 officers and 77 enlisted men, Capt. Benjamin Foulois, seen here, commanded this unit. The squadron first saw action in Mexico, pursuing Pancho Villa, before earning fame during World War I in France.

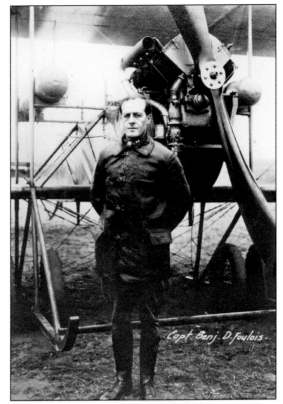

Officers and enlisted men of the First Aero Squadron stand at attention in front of some of the aircraft housed at North Island. Many of these men found themselves in France just a few years later, fighting in World War I.

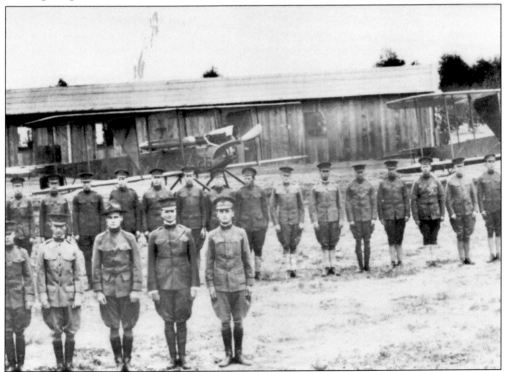

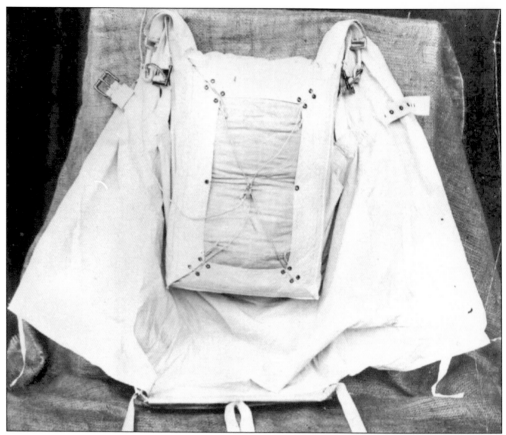

On March 8, 1915, Georgia "Tiny" Broadwick met with the U.S. Army Signal Corps and General Scriven, chief of the Aeronatucial Bureau at North Island, California. It was during this meeting that she demonstrated her "safety pack," used to safely jump out of airplanes. The airplane used for her demonstration, a Martin Tractor No. 31, was piloted by a military pilot, Oscar Brindley. During this jump, Broadwick's static line got caught, forcing her to cut the line and perform the first premeditated free fall from an airplane.

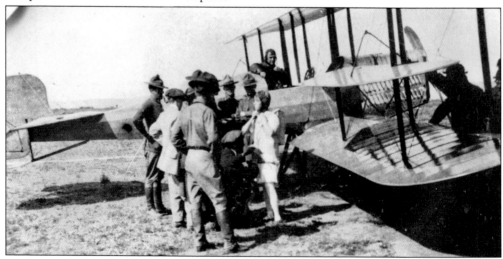

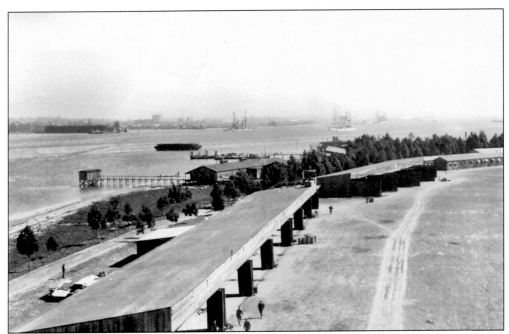

This is an image of the army facilities at North Island around 1915. These temporary buildings included hangars for aircraft storage, barracks, and office buildings. Several large warships can be seen in the background. As early as 1915, San Diego Bay was home to some of the largest and most advanced ships in the U.S. Navy's armada, just as it is today.

The reputation of San Diego as a premier training area for pilots had spread all the way to Europe. Pictured are Portuguese officers sent for flight instruction at North Island, c. 1915. These aviators are wearing coveralls and carrying wrenches because aviation engineering was being taught at North Island, along with flight instruction. Their instructor, George Hallett, is in the center.

As World War I continued, it became clear to military officials that aviation would play a crucial role in this and future wars. In 1917, Congress authorized the acquisition of North Island, and it became government property, serving as an official base for both army and navy aviation. In September 1917, Lt. Earl W. Spencer was ordered to take command of Naval Air Station (NAS) San Diego at North Island and establish a permanent training air station. Spencer remained in command until December 1919.

During World War I, activity at North Island increased at a fevered pitch; both aviators and flight-support personnel were trained at this site. By war's end, NAS North Island had trained 892 mechanics and 206 aviators. Pictured here is the interior of the quartermaster's school, where classes in aircraft assembly were taught in 1918.

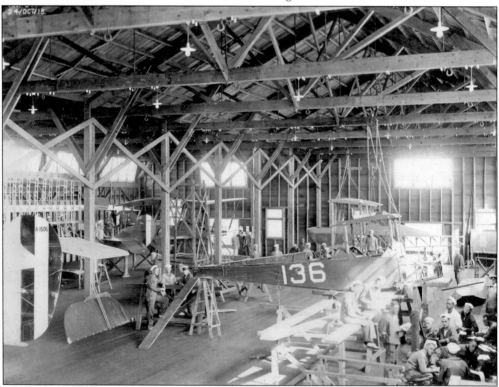

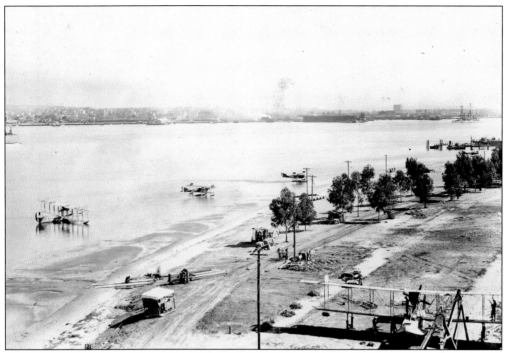

The busy nature of NAS North Island and the quickly developing city are seen here in 1918. The aircraft in the foreground is a Curtiss HS-2 flying boat, powered by a Liberty engine. Note the battleship at anchor in the bay.

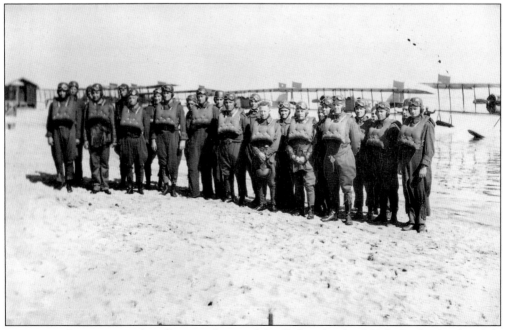

Lieutenant Simpson was the officer in charge of the flight school at NAS North Island on July 9, 1918. As World War I continued, the school grew rapidly. Pictured here is Lieutenant Simpson with a group of pilots and student fliers.

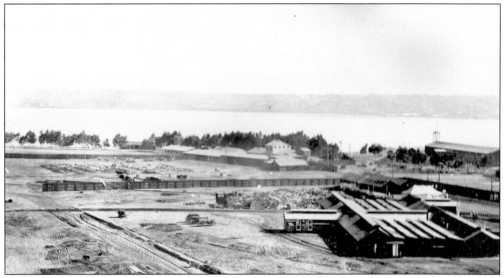

Construction on the island took on a fevered pitch after North Island was officially turned over to the government. New buildings included hangars, living quarters, and administration buildings. This panorama shows much of the construction taking place in 1918. The new mess hall and galley can be seen in the foreground. The army field on North Island was officially named Rockwell Field in 1917 after Lewis Rockwell, who died in an aircraft crash in 1912.

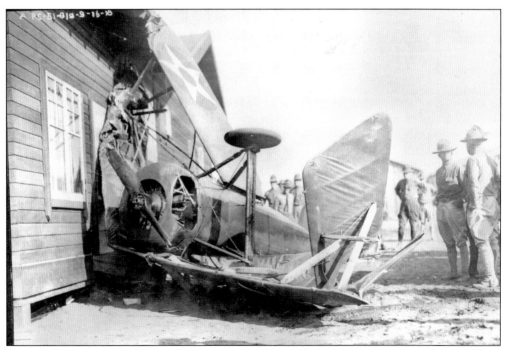

Army officials examine this accident scene involving a Thomas Morse airplane and a building on North Island. Such incidents were common during the early years of aviation. Although this pilot survived, not all were as lucky. At least eight military pilots died at North Island in 1918.

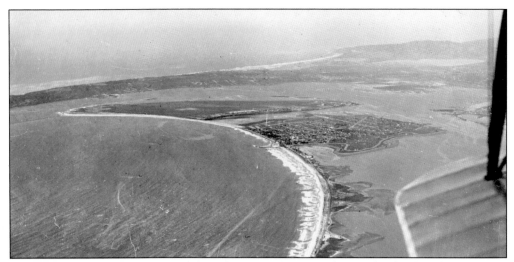

This striking aerial photograph of the Silver Strand, Coronado, North Island, and Point Loma was taken in 1918 or 1919. Note that the Spanish Bight has not yet been filled in. Even though there is a lot of new construction on the island, much of it remains open space, leaving much room for further growth.

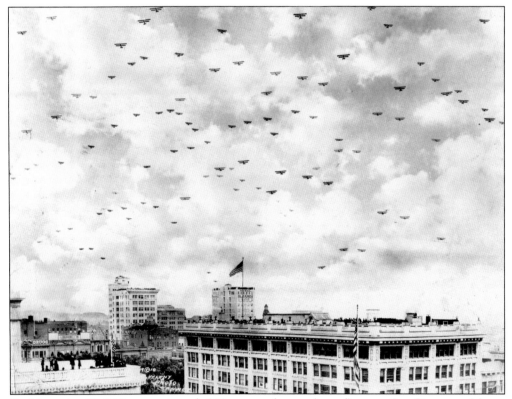

On November 27, 1918, approximately 200 army and navy planes flew over San Diego to celebrate the end of World War I. Many of these airplanes took off from North Island. Some of the aviators also performed aerobatics. Thousands witnessed the flight from San Diego's rooftops. Amazingly there were no mishaps.

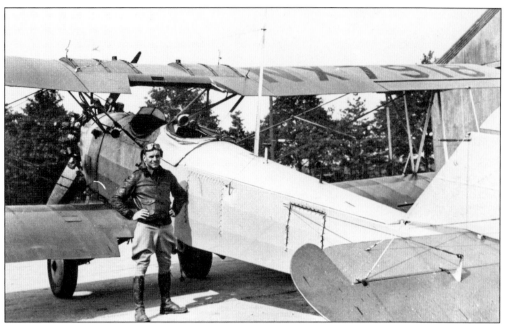

Another famous aviator, Jimmy Doolittle, was trained at North Island as a gunnery instructor during World War I. Doolittle also was among the 212 pilots who accomplished the Armistice flyover in San Diego at the end of the war. Logging many of his flight hours here, two of Doolittle's record-breaking long-distance flights ended in San Diego.

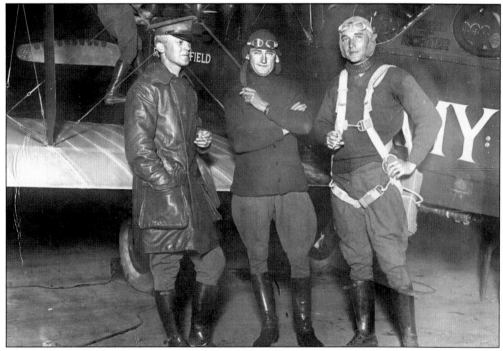

Another famed military aviator, Major "Hap" Arnold, arrived in San Diego in December 1918, taking over command of Rockwell Field at North Island. Major Arnold would go on to gain fame as the architect of America's bombing campaign against Germany during World War II.

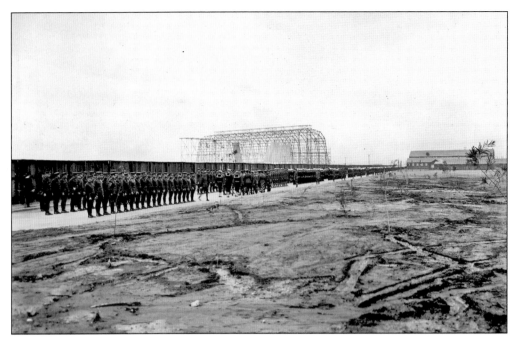

During the years immediately following World War I, the navy expressed a great interest in "lighter than air" technology. North Island was looked upon as an optimal site for dirigible activities, and construction of a dirigible hangar over 250 feet long was ordered. One such hangar is under construction in the background.

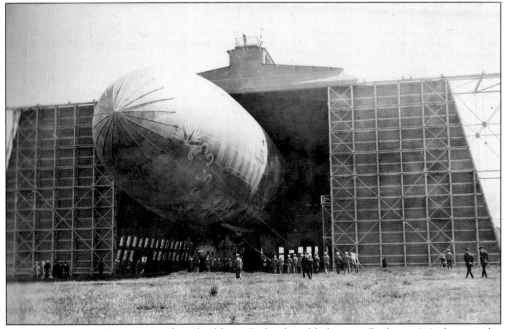

Non-rigid Airship C-6 emerges from building 17, the dirigible hangar. Built in 1919, this was the largest building on North Island. To commemorate the rollout, a gala party was thrown with many Hollywood stars in attendance, including Mary Pickford. The C-6 was lost in a crash in September of that same year, fortunately with no fatalities.

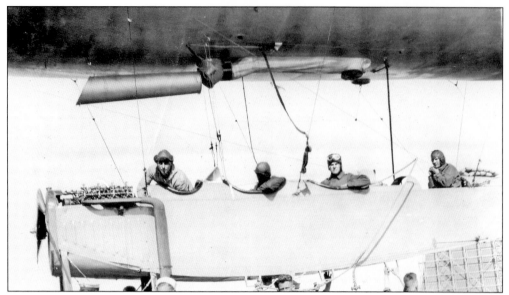

A large Goodyear B-18 gondola is manned by four navy men c. 1919. The front of the gondola appears to be a modified JN-4 Jenny. Proximity of the crew to the engine ensured passengers would get an unhealthy dose of wind and oil.

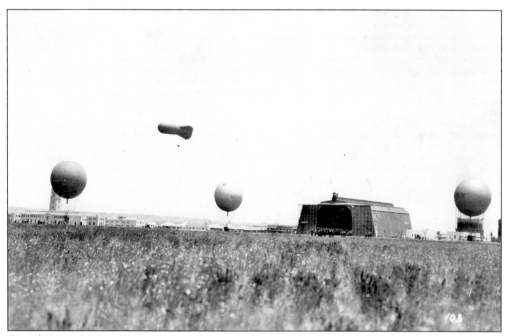

On July 15, 1920, Vice Pres. Thomas R. Marshall visited North Island. In honor of this occasion, a race was staged between three hydrogen-filled balloons. Unfortunately the race was a near disaster, as unpredictable winds sent the balloons flying in all different directions. Each balloon was forced to make an emergency landing, and no winner was announced.

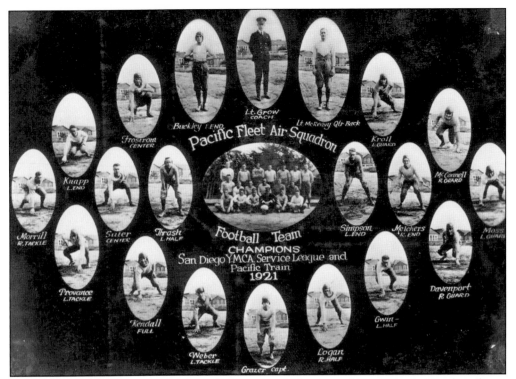

Could these be San Diego's first football champions? Members of NAS North Island's military football team are seen here. Even today, it is common for military bases to field teams in a variety of sports, including football, baseball, and basketball.

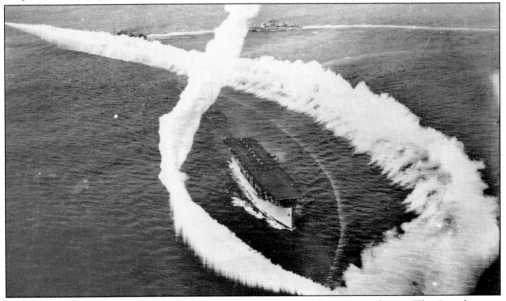

The USS *Langley* (CV-1) is masked in a smokescreen laid by two airplanes. The *Langley* was the United States' first aircraft carrier. Converted from the collier *Jupiter*, the *Langley* found a home in San Diego, establishing a long heritage of aircraft carriers stationed at North Island. Unfortunately she was lost early in World War II.

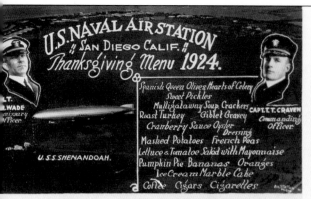
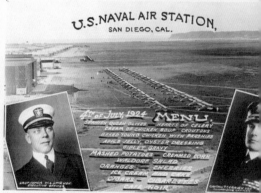

These are the menus from Thanksgiving and the Fourth of July in 1924 from NAS North Island. Judging from these very extensive offerings, the holidays must have been much anticipated. These menus were for officers and enlisted men alike. Of special note is the inclusion of cigars and cigarettes. Similar menus were also provided for Christmas.

The 1920s were a decade of numerous aviation firsts and North Island played a pivotal role in many of these firsts. The first nonstop transcontinental flight is celebrated by Lt. Oakley Kelly and Lt. John Macready on North Island on May 3, 1923. Taking off from Hempstead, New York, the trip, made in a Fokker T-2, was completed in 26 hours, 50 minutes, and 38 seconds.

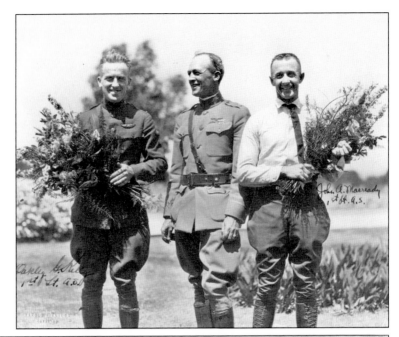

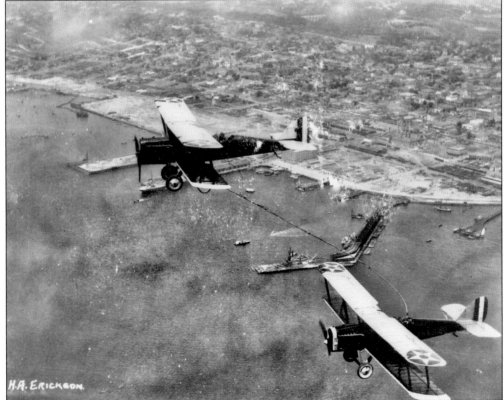

Another first occurred over North Island in June 1923. Two Army DH-4s performed the first in-flight refueling. The airplane accepting fuel was filled up twice and stayed in the air for 6 hours 39 minutes. Here the two aircraft can be seen refueling over San Diego Bay.

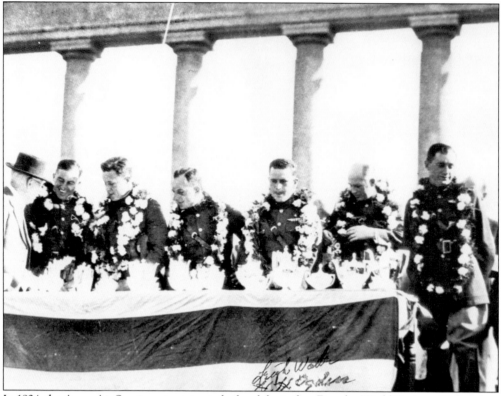

In 1924, the Army Air Service set out to circle the globe in four Douglas World Cruisers. Before they left from their official starting point in Seattle, Washington, maintenance work was accomplished on these aircraft at NAS North Island. On their return leg, they stopped off in San Diego.

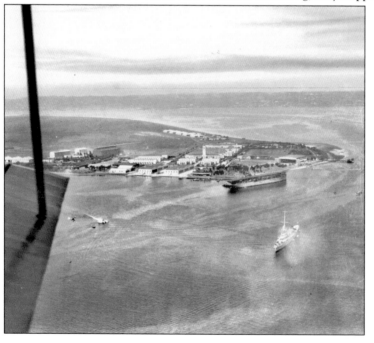

This is an aerial view of NAS North Island around 1925. The U.S. Navy's first aircraft carrier, the USS *Langley*, is at anchor in the bay. North Island certainly appears to be a busy place; the first of many permanent buildings have already been constructed.

Upon their return to Rockwell Field in January 1929, the crew of the Fokker C-2A Question Mark is all smiles after their successful record-breaking endurance flight. Flying over Southern California, the Fokker stayed aloft for 150 hours, 40 minutes, and 15 seconds. To keep the aircraft aloft, it was refueled in flight several times.

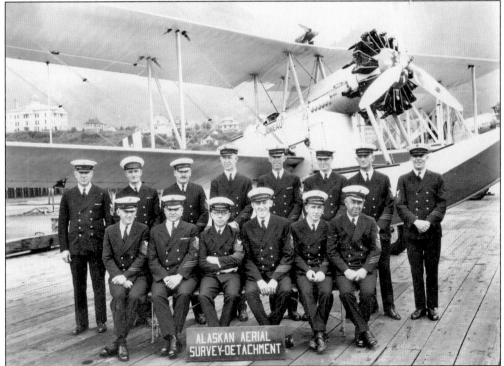

In an attempt to get a comprehensive understanding of Alaska's geographic topography from the air, a group of Loening OL-8A aircraft left North Island in 1929 to complete an aerial survey. The mission was a success, mapping 13,000 miles of Alaska. Pictured here are the navy officers who were involved in the expedition.

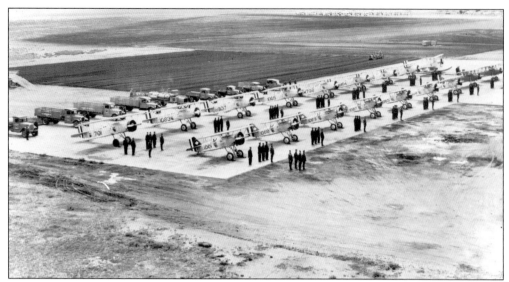

Inspection day was extremely important for the U.S. Marine Corps West Coast Expeditionary Force at North Island, pictured here around 1931. The aircraft in the front row are Curtiss F6C-4 Hawks and Curtiss N2C Fledglings. The second row contains Curtiss OC-2 Falcon observation airplanes and one Loening OL amphibian.

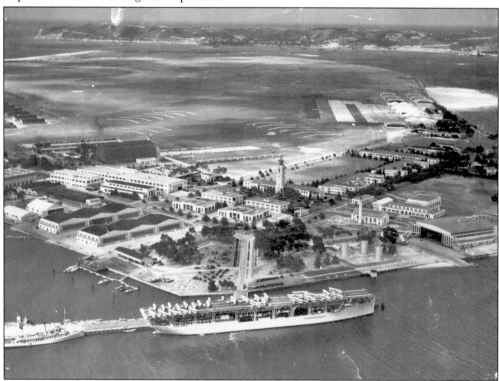

Only a few years away from the start of World War II, North Island has grown to a mature air station. The army left North Island in 1935, leaving the navy as its sole occupant. In the coming years, North Island would play a pivotal role in the defense of America, training pilots, and refitting ships being sent off to fight the Japanese.

Four

THE GOLDEN AGE
OF FLIGHT

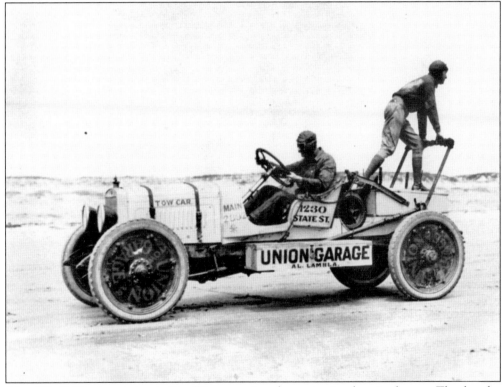

After World War I, aviation in San Diego continued to enjoy its place in the sun. The decades between the wars became a Golden Age of Aviation in San Diego. The end of the war meant that surplus pilots and aircraft were abundant, and many young pilots endeavored to make a living by thrilling onlookers with daring aerial exploits. Stunt flying at air meets became commonplace in this area. Ex-army pilot Clyde Pangborn was one of these youngsters overcome with aerial exhibition fever. On May 16, 1920, he attempted a car-to-airplane exchange in front of the tent city on Coronado Island. Here he is seen preparing for the transfer.

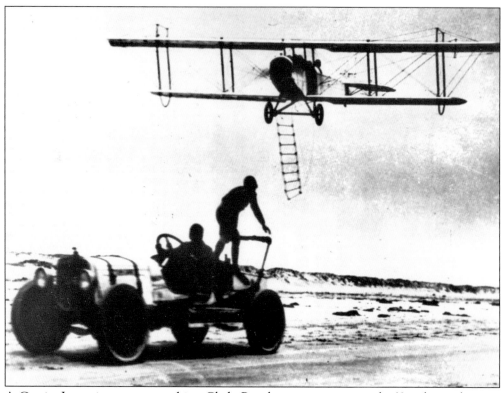

A Curtiss Jenny is seen approaching Clyde Pangborn at approximately 60 miles an hour as he prepares for his famous car-to-airplane transfer. Pangborn had successfully performed this maneuver the day before.

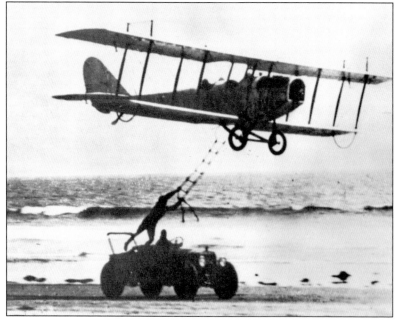

This is the moment of truth. Shortly after this photograph was taken, Pangborn lost his grip on the rope ladder and tumbled to the sand. Miraculously he only suffered a sprained shoulder and a small cut on his cheek. This small setback did not deter him from performing this stunt again.

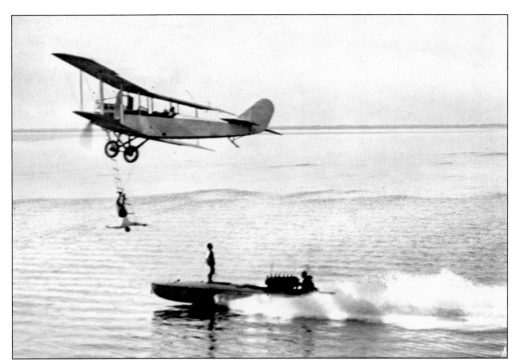

An unidentified daredevil is seen here hanging from a rope attached to an airplane. This death-defying feat is being performed over San Diego Bay. It is not known if the individual was attempting to transfer to the boat or if it was there only as a safety precaution.

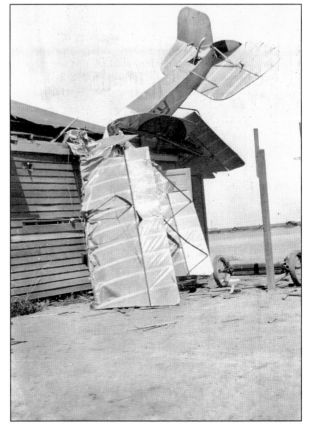

Flying in the 1920s was not a perfect art form. Seen here is an unidentified Curtiss JN-4 Jenny making an abrupt stop near Camp Kearney. The camp, known today as U.S. Marine Corps Air Station Miramar, had been a naval air station until recently when the marines took possession. Miramar earned fame in the movie *Top Gun* as "Fighter Town USA."

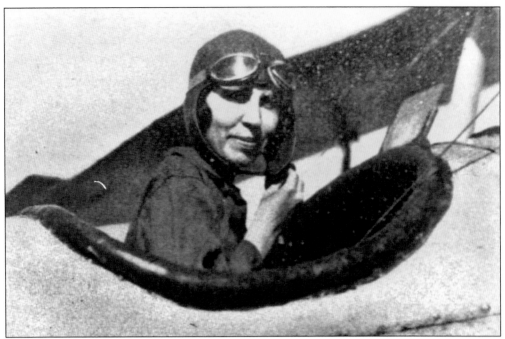

Flights soon became available to all, as small companies started offering air transport to the public. Carl Oelze established the San Diego Airport and Flying School in 1922, located at present-day Barnett Avenue. Oelze operated his small flying service for five years. When Oelze died in 1927, his wife, Loretta (pictured here), took over operations. She is believed to be the only woman operating such a service in the United States at the time.

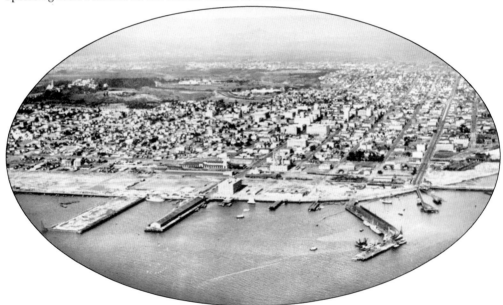

In September 1922, T. Claude Ryan, an ex-army reserve pilot, opened up a flying service and school in downtown San Diego. Directly behind the Broadway Pier, seen on the far left, is the runway where Ryan offered sightseeing tours for as little as $2.50 for a "20-mile air ride." Business picked up when a carnival located next to Ryan's runway.

In addition to sightseeing tours, Ryan provided flying lessons to many eager students. He charged $200 for an entire course. Pictured on the left is one of Ryan's first students, known as "Smitty." The girl wanted to have her picture taken with an aviator.

Ryan soon solicited tour buses to provide customers for his sightseeing air-ride tours, which came from as far away as Los Angeles. After moving his operations from the Broadway location to Dutch Flats, it was not long before Ryan started a passenger service between San Diego and Los Angeles. Converting standard J-1s to carry up to four passengers and renaming them the Ryan Standard, these airplanes became the staple of Ryan's business.

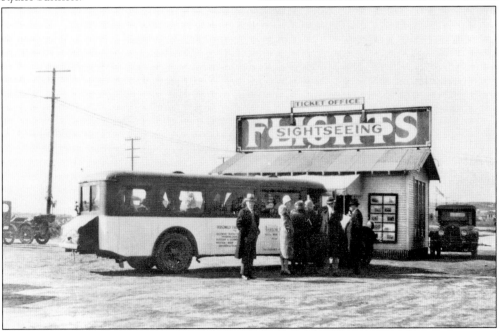

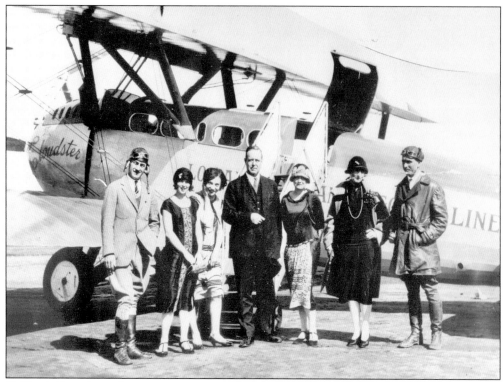

T. Claude Ryan began his passenger service between Los Angeles and San Diego in March 1925. Pictured in front of a Cloudster is Ryan (right) with John Bacon (center), the mayor of San Diego. This Cloudster, designed to hold up to 10 passengers, was built in 1920 by Donald Douglas to fly a nonstop transcontinental flight, but the flight was never completed. In 1926, Ryan converted this aircraft and it became the flagship of the San Diego–Los Angeles passenger service route.

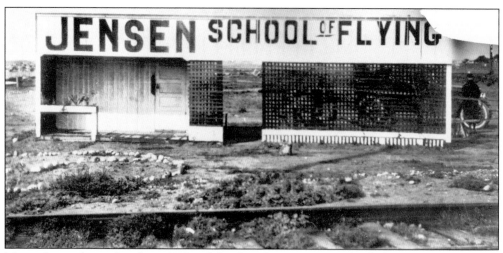

Martin Jensen learned to fly in 1919 and developed a great passion for flight. In December 1924, Jensen started a small flying school, the Jensen School of Flying, at Dutch Flats where the central post office now stands.

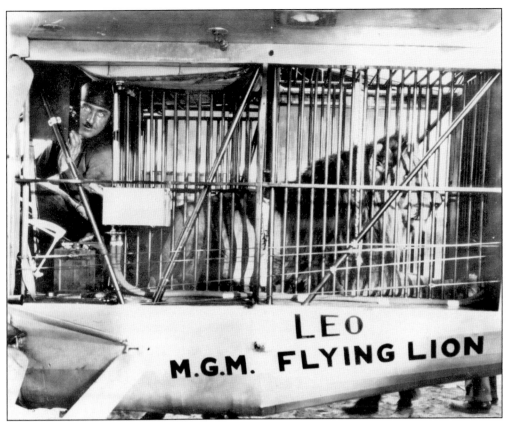

Perhaps the most unusual Ryan or Mahoney aircraft built was this B-1 Brougham. Designed and constructed for a 1927 publicity tour of the United States, this airplane had a large built-in cage constructed to carry Leo, the MGM lion. Unfortunately the airplane overheated in Arizona and made a crash landing with Leo onboard. Both the pilot and lion were okay, but the pilot had to walk for several miles for help. When the rescue party returned a few days later, Leo was hungry and angry, but alive.

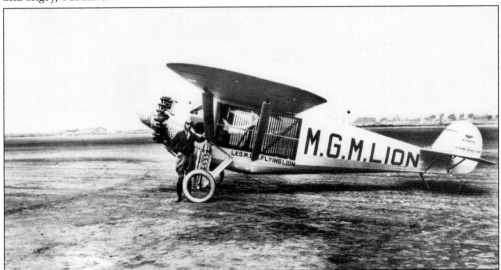

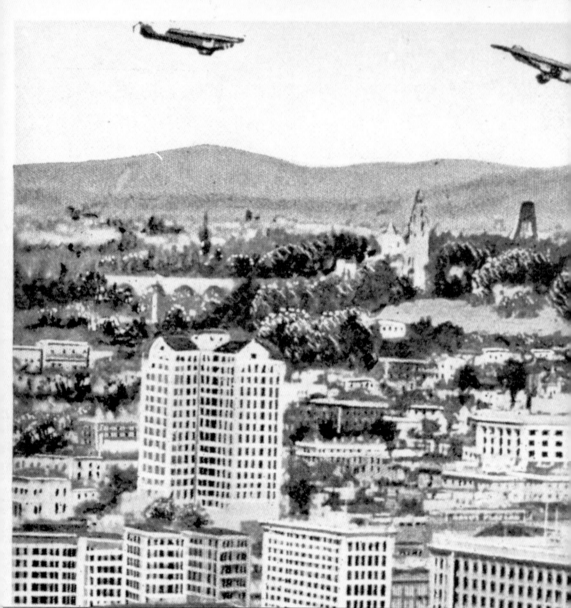

This postcard view of San Diego dates from the 1920s. Two aircraft fly above downtown. Visible are the El Cortez Hotel and Balboa Park. The Ford Building, the current home of the San Diego Air and Space Museum, had not been constructed at this time. The aircraft seen here appear

to be one of T. Claude Ryan's designs, attesting to the fact that this manufacturer had already become famous.

Jimmy Russell opened a parachute-manufacturing company on Kettner Boulevard in December 1925. His parachute designs were soon considered among the safest in the world. Included in Russell's designs is a parachute large enough to safely set an airplane on the ground.

Miss San Diego 1926 stands in front of a San Diego–built Ryan M-1. The Ryan M-1, inspired by the Wright-Bellanca WB-1, is the first monoplane produced in a series in America. It was designed by T. Claude Ryan and calculated and drafted by Bill Waterhouse. This aircraft's first flight took place on February 14, 1926, from Dutch Flats, California.

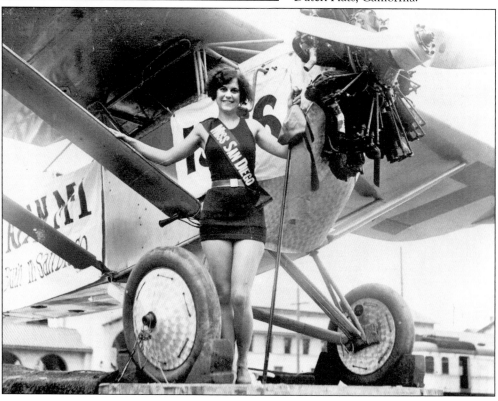

Prohibition was in full swing in America in late 1926, but the beer business was running as usual in Mexico. When a flood took out the main road between the brewers in Mexicali and Tijuana, Ryan was called in to keep the supply route open by air. Here kegs of beer are loaded onto the Cloudster, a Ryan aircraft usually reserved for transporting people.

In January 1927, George Prudden started the Prudden San Diego Airplane Company. Pictured here is one of the two airplanes produced by this company, which never became a commercial success. George Prudden's brother, Earl, eventually became vice president of the Ryan Airplane Company.

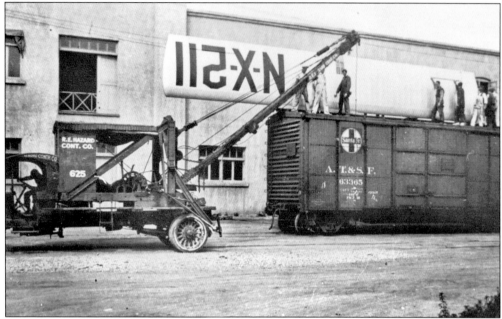

Charles Lindbergh made the first solo flight from New York to Paris on May 21, 1927. The airplane he used, the *Spirit of St. Louis*, was built by Ryan Airways in San Diego in only 60 days. Here the wing, which was constructed on the second story of a building that once housed a fish cannery, is being lowered onto a truck. On April 28, Lindbergh piloted this plane on its first flight.

Lindbergh took the *Spirit of St. Louis* on several test flights above San Diego. Here he guides the plane in a turn above Coronado. Note the absence of a front canopy; in its place, an extra gas tank was fitted. Lindbergh left San Diego on May 10, 1927, for New York, where he would stage his legendary flight.

This rare photograph is a close-up of "Lucky Lindy" as he makes his victorious return to San Diego in September 1927. Over 60,000 admirers crowded Balboa Stadium to welcome him. This stadium welcomed many other important visitors also, including President Wilson in 1919 and the Beatles in 1965.

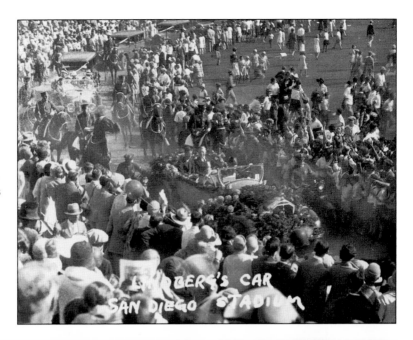

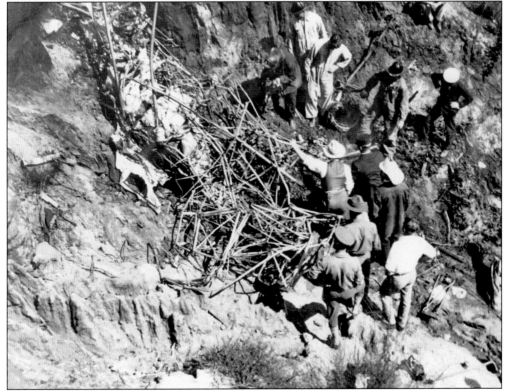

On August 10, 1927, navy lieutenants George Covell and Richard Waggener were killed instantly when their Tremaine Hummingbird monoplane crashed in the fog at Point Loma. The men were flying north to participate in the Dole Air Race, which offered a $25,000 prize to the winner of the Oakland-to-Hawaii race. Here rescue workers work to recover their bodies.

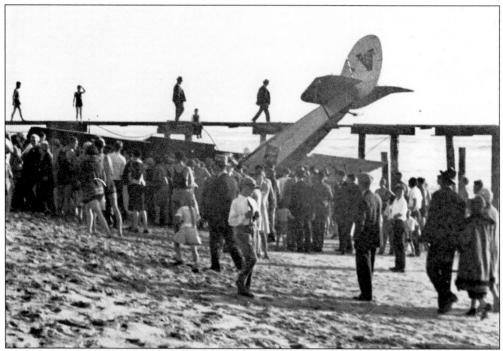

On October 2, 1927, Harold and Dan Tibbetts were performing their double-wing walking stunt over Mission Beach when the airplane's motor quit. The pilot made a deadstick crash landing on the beach and suffered a black eye. The Tibbetts brothers were unhurt, but quite shaken up.

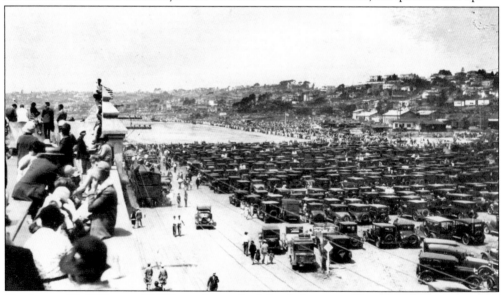

On August 16, 1928, over 50,000 people watched the dedication of San Diego's new municipal airport, Lindbergh Field. Flyovers and parachute jumps were included as part of the ceremonies. Interestingly this photograph was taken from atop the old fish cannery building where Lindbergh's *Spirit of St. Louis* was built. Within a few years, several companies would be offering flights out of Lindbergh Field, including Pickwick Airlines, Western Air Express, American Airlines, and United Airlines.

Emilio Carranza watches as his Ryan B-1 Brougham is fueled. Known as "Mexico's Lindbergh," Carranza flew nonstop from Mexico City to Long Island in 1928 on a goodwill flight. The B-1 was Carranza's choice of airplane because he knew that the San Diego–based Ryan Airplane Company had a record of producing reliable aircraft. Unfortunately Carranza crashed and died on his return trip while flying through a violent thunderstorm.

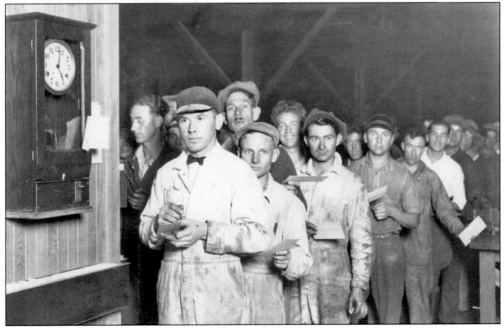

Workers are seen here as they line up to begin work at the Ryan factory around 1928. They will probably be helping to build the famous Ryan B-1 Brougham. T. Claude Ryan was active in his airplane-building businesses until the late 1960s and could often be seen wandering through the factory areas.

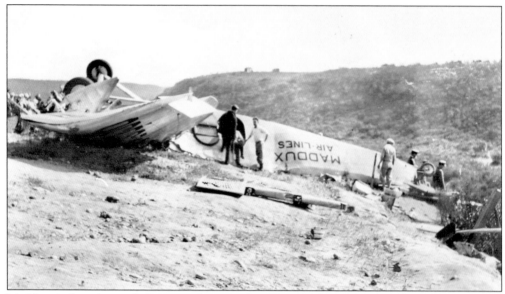

Maddux Airlines began daily service between San Diego and Los Angeles in 1927. On April 29, 1929, an army reserve pilot, flying a Boeing PW-9, crashed into a Maddux Ford Trimotor while he was stunting. All five people onboard the Trimotor were killed, along with the army pilot. This was the first midair collision of a commercial airliner in the United States. According to a widely reported false rumor, the army pilot was trying to impress his girlfriend riding in the Maddux plane. She was not onboard this flight.

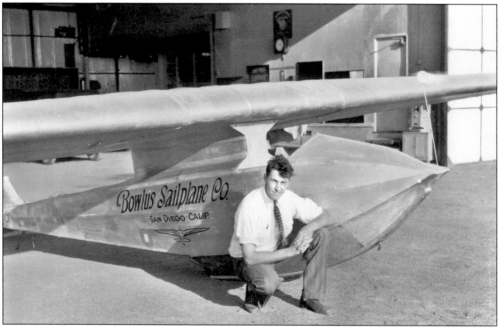

Non-powered aircraft were also in abundance in San Diego. The unquestioned leader in this soaring community was Hawley Bowlus. An integral part of the Ryan Airplane Company, Bowlus designed numerous gliders and set many soaring records. In November 1929, he opened his own Bowlus Sailplane Company.

News of San Diego's aviation growth spread quickly, and the area began attracting many people interested in this field. To become more involved in the area's aviation excitement, Marvel Crosson relocated to San Diego. Seen here, she celebrates her women's altitude record of almost 24,000 feet, set in 1929. Unfortunately Crosson died that same year in Arizona, when her plane crashed.

Ruth Alexander, seen here with her airplane, set a women's altitude record of 27,000 feet over San Diego in July 1930. In September of that same year, she flew nonstop from Vancouver, Canada, to Agua Caliente in Baja Mexico. Unfortunately she died on September 18, 1930, when her plane crashed at Point Loma.

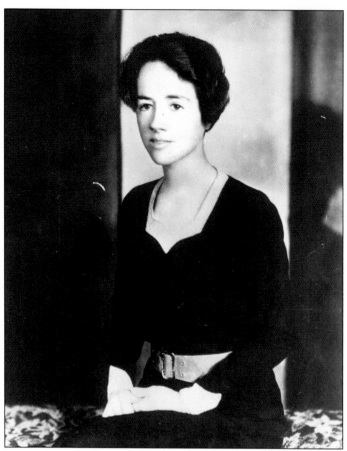

On January 29, 1930, Anne Morrow Lindbergh attended a one-day glider course at the Bowlus Gliding School at Lindbergh Field. Her husband, Charles Lindbergh, took the course a couple of days prior to her. Anne Lindbergh's first flight originated from the top of Mount Soledad in San Diego. She was the first U.S. woman to get her first-, second-, and third-class glider licenses, qualifying for all three in a single flight.

Theodore Gildred's Ryan Brougham is admired by onlookers in Santa Elena, Ecuador. Gildred made the 4,200-mile trip from San Diego to Quito in 1931. A groundbreaking flight, this goodwill mission improved relations between Ecuador and the United States.

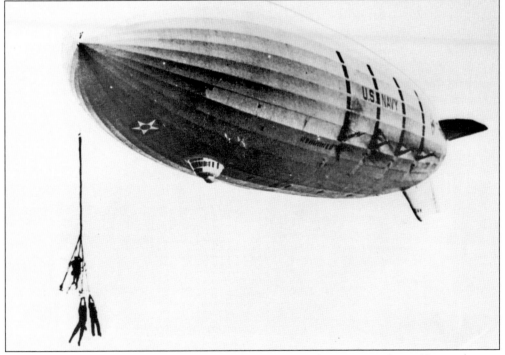

On May 11, 1932, the navy dirigible USS Akron attempted to moor at Camp Kearny, known today as Miramar. A water ballast bag broke during the maneuver, and the giant ship rose with three sailors, part of the ground handling team, while holding on to a rope. Two sailors fell to their deaths as cameras rolled, while one was hoisted onboard to safety.

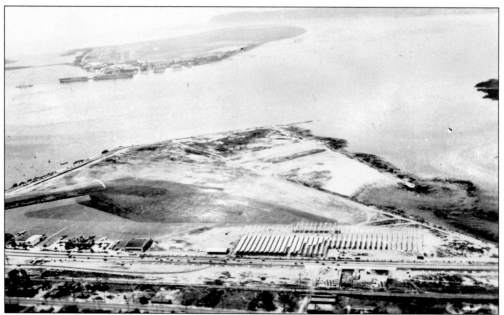

San Diego experienced an incredible boom in the aircraft design and building industry as large firms started in, or relocated to, this area. Reuben Fleet moved Consolidated Aircraft Corporation from Buffalo, New York, to San Diego in 1933. This decision became momentous for San Diego; over the next decades the corporation provided tens of thousands of jobs. Seen here in the foreground, the Consolidated plant is under construction at Lindbergh field in 1935. North Island can be seen in the distance.

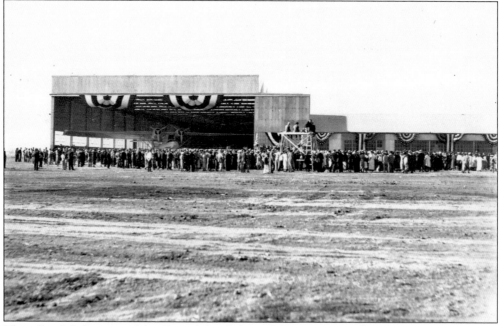

The official dedication of the Consolidated Aircraft Factory at Lindbergh Field took place on October 20, 1935. The prototype of the Consolidated PBY, an airplane that would play a vital role in World War II, can be seen inside the building.

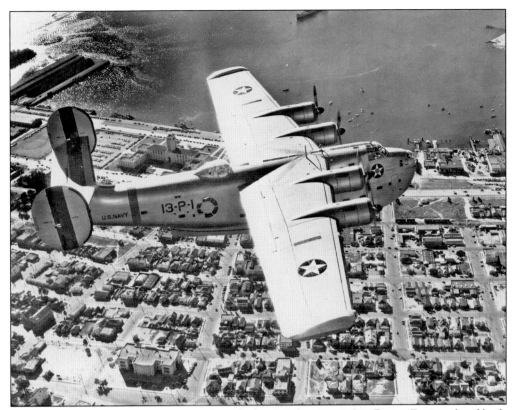

This is a Consolidated PB2Y-2 Coronado in flight over downtown San Diego. Designed and built in San Diego, the Coronado was one of the largest aircraft in the United States' prewar arsenal. The U.S. Navy insignia of Patrol Squadron 13 can also be seen.

This suggestive shot was used to promote W. Arnett Speer's flying school located at Dutch Flats. Speer's operation lasted from 1934 until the outbreak of World War II. The women in the photograph are members of the Lady Birds Flying Club.

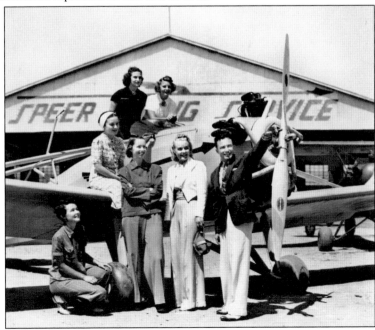

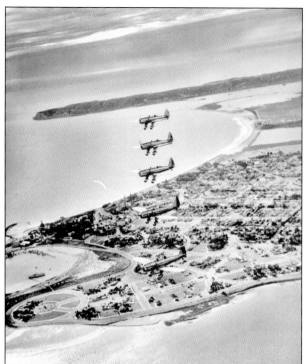

After T. Claude Ryan sold his interest in the original Ryan Companies, he formed the Ryan School of Aeronautics on June 5, 1931. On May 26, 1934, he formed a new Ryan Aeronautical Company, and the school eventually became a subsidiary. The first aircraft produced by this new Ryan Aeronautical Company was the S-T in 1934. A formation of these aircraft can be seen here flying above Coronado Island.

This is a publicity shot for the movie *Wings of the Navy*, filmed on North Island in 1939. Starring John Payne (left), George Brent (middle) and Olivia de Havilland (right), the film highlighted America's naval aviation might. Soon put to the test, San Diego would become an integral part of the effort to win World War II.

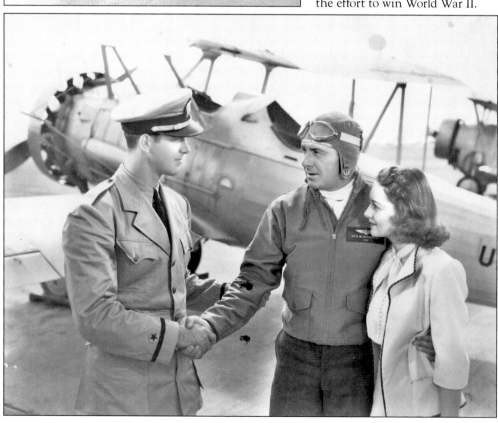

Five

WORLD WAR II

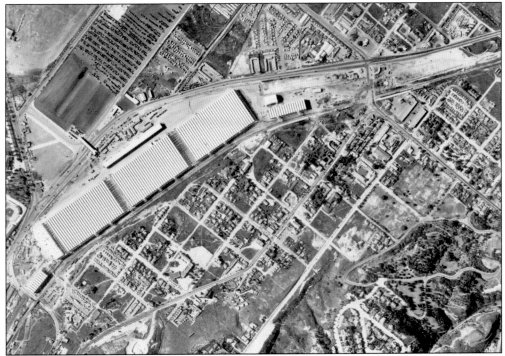

Soon after the United States entered into World War II, the American aircraft industry became the largest single industry in the United States and the largest aircraft industry in the history of the world. In response to the increase in aircraft production, Consolidated Aircraft Company, also known as Convair, subcontracted with T. Claude Ryan and Fred Rohr to help meet the high demand for aircraft. The enormous aircraft production contracts required a tremendous mobilization of machine tools, labor, and production engineering. Even before the start of World War II, Consolidated was expanding its manufacturing facilities. This construction would be invaluable as Consolidated would contribute greatly to the war effort. Consolidated Plant Two, located about 1 mile north of Lindbergh Field, was dedicated on October 20, 1941. This building is still in use, housing a division of Space and Naval Warfare Systems (SPAWAR).

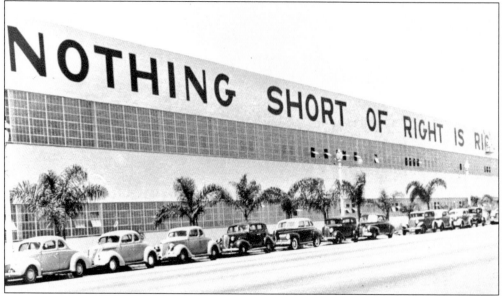

Reuben Fleet's slogan for Consolidated Aircraft in 1941 was "nothing short of right is right." He had the slogan painted in large letters on the side of Consolidated's Plant No. 1, reminding everyone to do their best. This slogan represents Fleet's dedication to perfection and instilled pride in company workers.

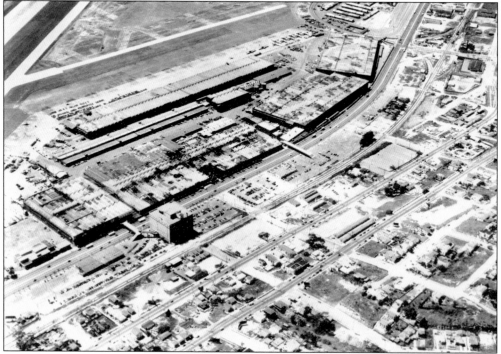

After the surprise attack on Pearl Harbor, San Diego was considered a potential target for enemy attack. The city of San Diego quickly mobilized to defend itself and the coast. Camouflage nets were used to hide major aircraft-manufacturing facilities, which can be seen here covering the three large consolidated buildings in the upper left.

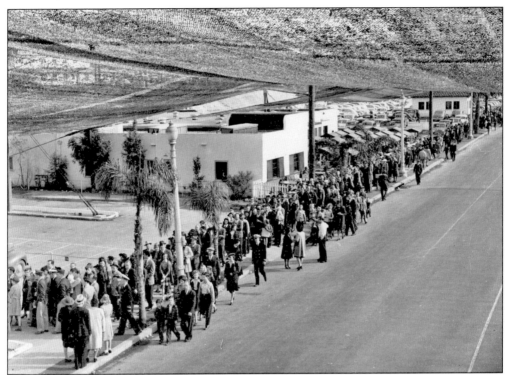

Employees, visitors, and their families line up at one of the entrances to Consolidated Aircraft. The camouflage nets covering the buildings can be seen above. Employees and visitors were here to enjoy one of the many open houses that took place for plant workers and their families.

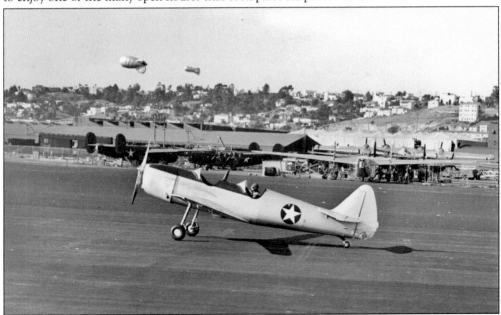

This United States Army PT-25 is landing at Lindbergh Field in front of the Consolidated Aircraft Plant No. 1. Several newly completed B-24s can be seen in the background. Barrage balloons, put in place to discourage low-level attacks by the Japanese, can also be seen flying over the plant.

Isaac M. Laddon was Consolidated's chief engineer during World War II. He was later promoted to executive vice president, general manager, and director. Laddon designed Consolidated's PBY and B-24 aircraft. These two aircraft types played a crucial role in helping the United States win the war. Laddon also was the lead designer on the B-36, which would be the largest and most advanced bomber during the very early stages of the cold war.

Arguably the most significant aircraft built by Consolidated during the war was the B-24. Not as well publicized as the B-17, the B-24 Liberator was the most commonly used bomber in World War II. It was first tested above San Diego harbor in December 1939. The Consolidated plant in San Diego built 6,724 of the 18,482 B-24s produced for the war effort.

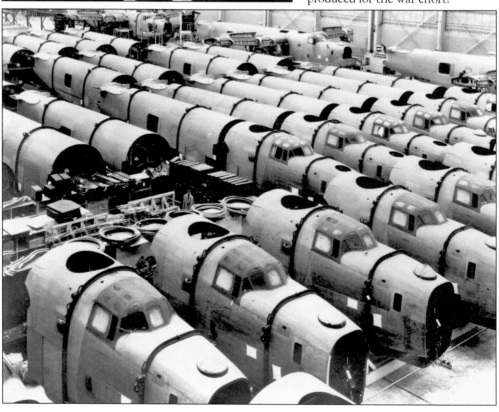

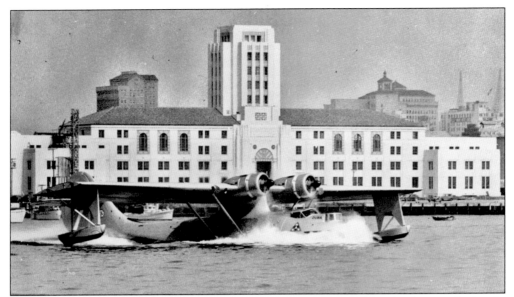

Also built by Consolidated Aircraft, the PBY Catalina can be seen here landing on the bay in front of the San Diego County building. The Catalina was one of the most versatile aircraft used during World War II. Because of its adaptability and exceptional range, it was used in all theatres, performing both patrol and combat roles.

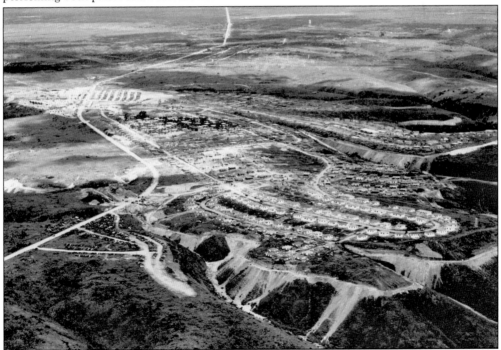

To address the housing shortage in San Diego, the federal government approved construction of 3,000 units of public housing on a plateau northwest of Mission Valley. The project was entitled the Linda Vista, or Kearney Mesa, Defense Housing Project. Credit was given to Rueben Fleet for his advocacy of this endeavor. Construction began on March 5, 1941, and some housing was opened to tenants by January 1, 1942.

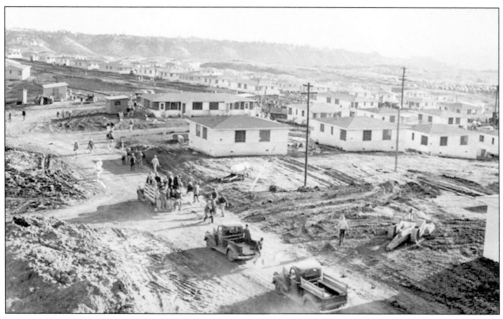

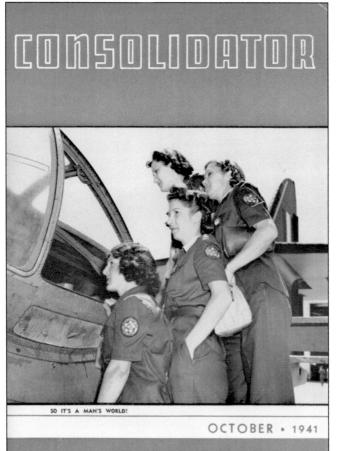

CONSOLIDATOR

SO IT'S A MAN'S WORLD!

OCTOBER • 1941

Construction continued on new housing as employment at Consolidated's San Diego plant increased from 4,744 employees in February 1940 to 45,190 in February 1943. The Ryan Aeronautical manufacturing facility also increased from 470 employees in January 1940 to 4,991 in December 1943 before further increasing to 8,500 by the war's end.

In response to a request from the Office of Production Management in Washington D.C., Rueben H. Fleet announced that Consolidated would start a program to train and employ women in manufacturing aircraft. Work included light mechanical operations and machine and precision assembly work. Preference was given to wives and relatives of men who were already employed at Consolidated.

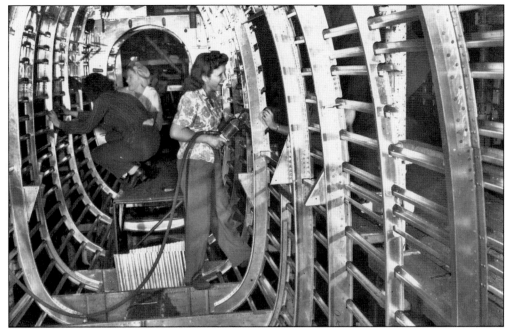

In September 1941, Consolidated hired 40 women as an experiment, assigning them to work at the San Diego plant building B-24 bombers. These women were such great workers that their numbers grew to several thousand within a 12-month period. By 1943, employment at Consolidated peaked to 41,000, of which 40 percent were women.

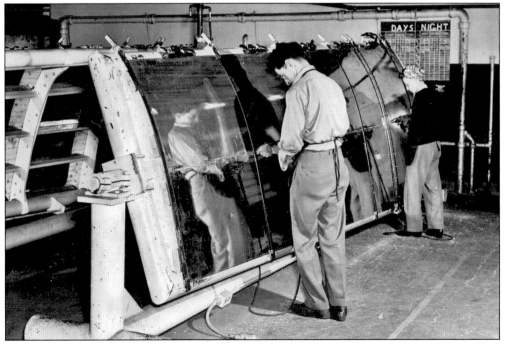

As women continued to prove their worth and their numbers increased in the workforce, they were often found working side by side with their male counterparts. Here two Consolidated employees work together to build a wing section.

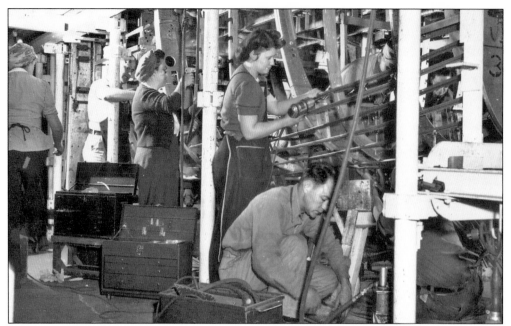

Two women install rivets on a B-24 at the San Diego Consolidated Aircraft Plant. Such women workers were affectionately called "Rosie the Riveter" and made up a very large percentage of the industrial workforce during World War II. Many people remarked that "these are the girls who are keeping 'em flying."

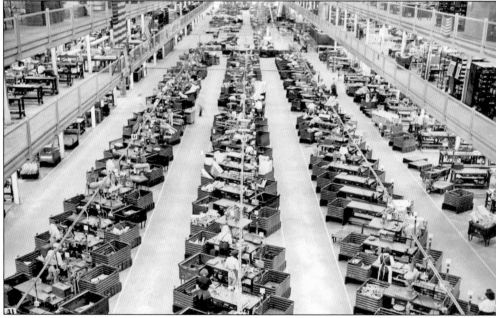

Consolidated Vultee Aircraft Corporation was formed in March 1943 with the merger of Consolidated Aircraft and Vultee Corporations. Both companies had been operating independently under the umbrella of the Aviation Corporation. Soon the merged companies changed their name to Convair. Seen here is one of the many assembly lines that were a part of the ever-growing Convair aircraft company.

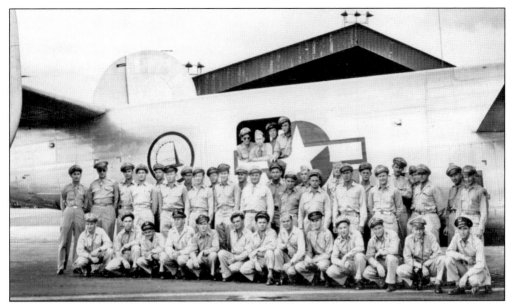

Convair formed its own air transport service called Consolidated Airways, Inc. to help meet the needs of the military during World War II. Using their own B-24s, Consolidated Airways, which became known as Consairways, carried personnel and cargo and delivered aircraft to the Pacific theater.

Joseph Famme's career began at Consolidated on January 25, 1936, as a mechanical engineer. Over the next few years, he was promoted to assistant project engineer and then to chief project engineer for the B-24 Liberator bomber. In April 1944, Joseph Famme and 14 other Convair employees were sent as technical representatives to England, reporting to the Eighth Air Force under Gen. Jimmy Doolittle's command. Their mission was to support the outfitting and repair of B-24s prior to the D-Day invasion of France.

This is an image of the last San Diego–built B-24 as it rolls off the assembly line. By this time, the Liberator had been refined for greater range and increased armament from the very early models. B-24 Liberators logged more flight hours than most other aircraft used during World War II.

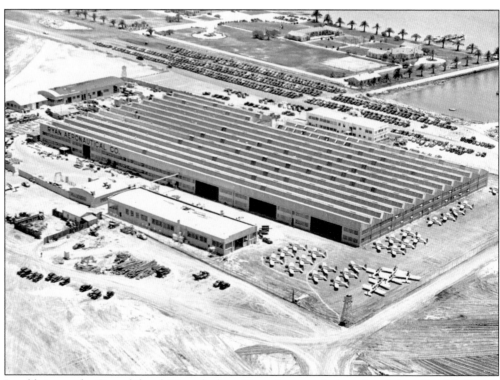

In addition to the Consolidated Aircraft plant, Ryan Aeronautical produced aircraft at Lindbergh Field. This aerial shot shows the Ryan plant, which specialized in producing aircraft used to train new pilots. The Ryan PT series originated from an earlier sport trainer model.

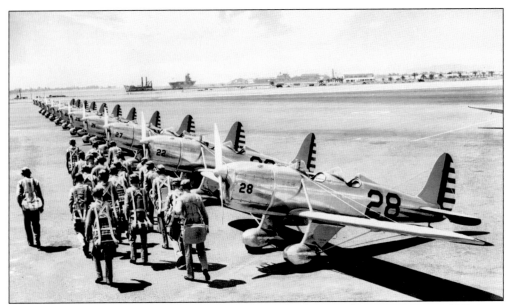

To meet the high demand for pilots, the Ryan Flying School received a contract to train U.S. Army aviators. More and more pilots were needed to fly the many planes coming off the production lines. The privately owned Ryan Flying School trained army pilots not only at Lindbergh Field but also at Hemet, California, and Tucson, Arizona. Seen here are a group of army cadets approaching their PT-20As.

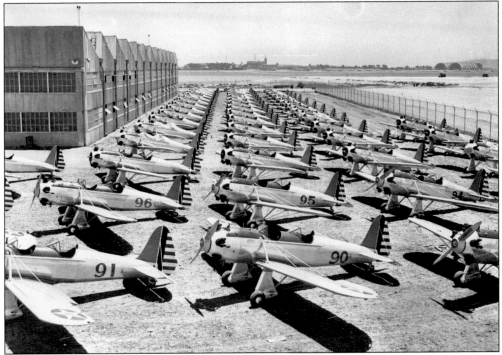

Numerous PT-21s are lined up outside the Ryan factory at Lindbergh Field anxiously awaiting cadets. Ryan companies not only built the aircraft used for training, they also performed the actual training of many prospective pilots.

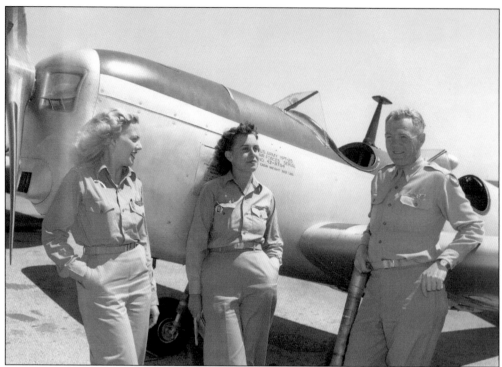

The army was receptive to having women serve in certain areas of aviation. One of these groups was the Women's Army Auxiliary, or WACs. Among other duties, these WACs worked in listening posts, ready to alert people of approaching enemy attacks. Two WACs are photographed here in front of a Ryan YPT-25.

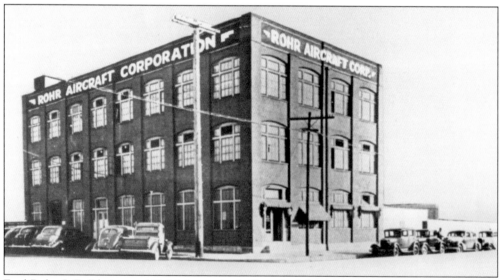

Fred Rohr, J. E. Rheim, and E. M. Lacey had all worked for the Ryan Aeronautical Company early in their careers. Together they formed the Rohr Aircraft Corporation. This picture, taken in 1940 or 1941, shows Rohr's first San Diego plant. The company produced power packages for the B-24 and PB2Y-3 during World War II. Solar, another San Diego company, also produced similar components.

During the war, thousands of workers poured into San Diego from all over the country. Many of these prospective employees were inexperienced, so extensive training in aircraft workmanship and engineering were needed for rapid production. The Ford Building, which was constructed in Balboa Park in 1935 for the California Pacific International Exposition, housed a vocational school to train these men and women. This historic building is now home to the San Diego Air and Space Museum.

Students are seen here learning the basic structure of an airplane at the vocational training school that was housed in the Ford Building in Balboa Park. Note the mural in the background, which can still be seen at the San Diego Air and Space Museum.

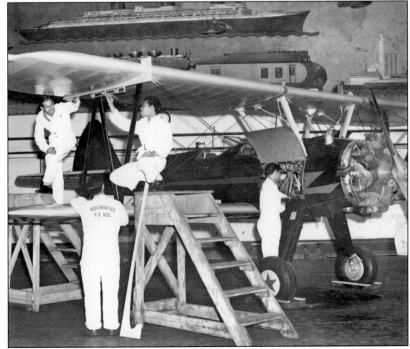

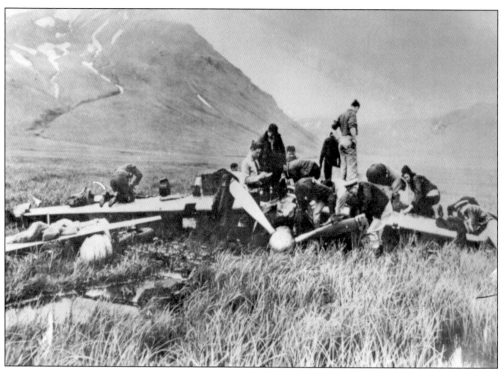

A wrecked Zero fighter was recovered on the Aleutian Islands and brought to San Diego's North Island for repairs. The fighter was reconstructed to gain a better understanding of enemy fighter capabilities such as climb rates, armor, speed, and range.

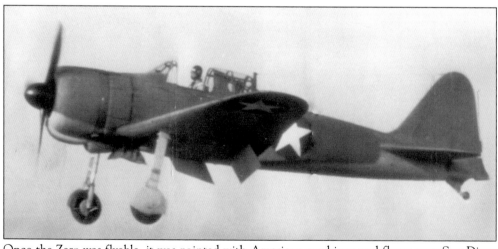

Once the Zero was flyable, it was painted with American markings and flown over San Diego several times for testing. Hundreds of aircraft spotters were trained in the area, yet no reports were received of an unidentified aircraft.

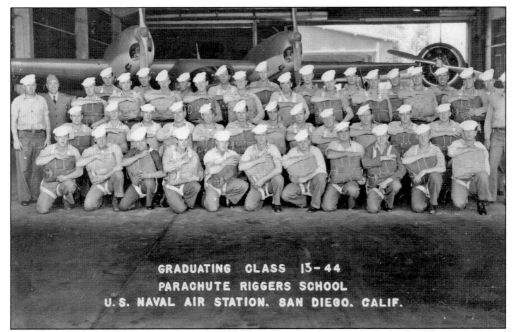

GRADUATING CLASS 13-44
PARACHUTE RIGGERS SCHOOL
U.S. NAVAL AIR STATION, SAN DIEGO, CALIF.

All types of testing, training, and aircraft maintenance were performed at Naval Air Station North Island during World War II. These parachute riggers are seen posing for their graduation photograph in 1944.

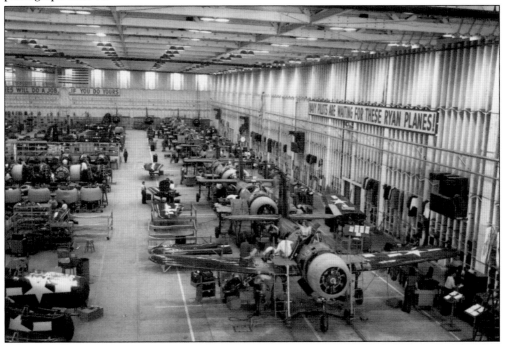

The Ryan FR-1 Fireball was designed for the navy in 1945. Seen here in an assembly line at the Ryan plant, this innovative plane was a composite propeller and jet-powered aircraft. Unfortunately the development of this aircraft was too late in the war for it to see any combat. New, all jet-powered aircraft would soon replace the Fireball, making its service life very short.

North Island was visited by hundreds of warships during the war, including many aircraft carriers. Seen here at port is the USS *Yorktown*, which would be destroyed in a few months at the Battle of Midway.

At the end of the World War II, America was left with an incredible amount of surplus war material that was no longer needed. Seen here is San Diego's "mothball fleet" that included many obsolete, small aircraft carriers.

Six

THE COLD WAR AND BEYOND

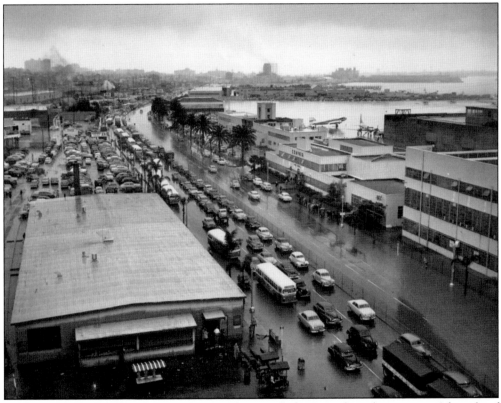

At the end of World War II, America entered a period of unprecedented prosperity. After a brief transition of San Diego's economy from a wartime one to a peacetime one, the city also joined in this economic and cultural growth. Seen here is activity at Convair's Lindbergh Field plants on an unusual rainy day in San Diego. Perhaps San Diego grew too fast; as the population exploded, air transportation tried to keep up with demand. In addition, the aviation industry thrived in the postwar period and San Diego remained on the cutting edge. San Diego is still a leader in aerospace development to this very day, as numerous aircraft corporations are still located in the area.

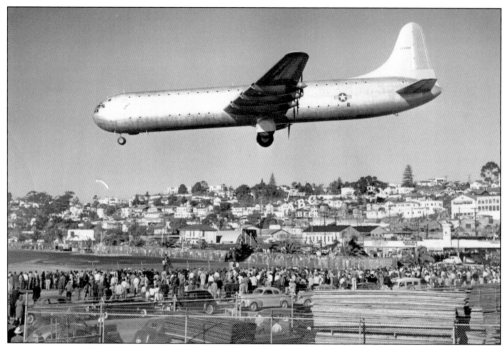

One of the military aircraft that Convair built after World War II was the B-36 Peacemaker, a bomber with unprecedented range and payload. A variant of the B-36 was the XC-99, seen here on arrival at Lindbergh Field. The XC-99 was a transport aircraft originally built for the U.S. Air Force and first flown in 1947. At this time, the XC-99 was the largest land-based, piston-driven aircraft ever built.

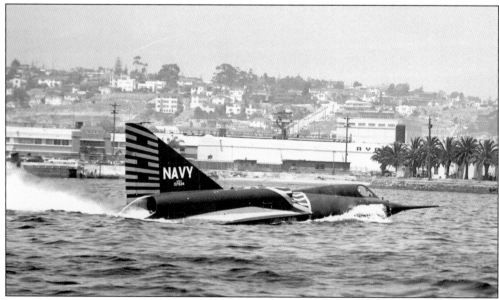

Perhaps the most unusual aircraft built by Convair was the F2Y Sea Dart. This aircraft was a supersonic fighter that could land and take off from water. The Sea Dart proved an unruly aircraft to control, so the program was laid to rest with only a few being built. The Sea Dart is seen here taxiing home after a test flight in San Diego Bay.

Theodore Hall, Convair's chief development engineer, was fascinated with the idea of an "air car." Seen here is Hall's Model 118 on approach to Lindbergh Field, built by Convair in 1948. Because of the high cost and limited public interest, the project never got into the production stage.

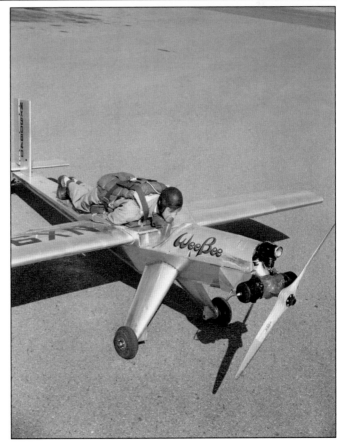

Employed as engineers at Convair in 1948, Ken Coward, Bill Chana, and Karl Montijo decided to build the world's smallest plane. Their creation, called the Wee Bee, was controlled by a pilot lying on his stomach. The airplane's small two-cylinder engine set the top speed of the Wee Bee at 82 miles per hour.

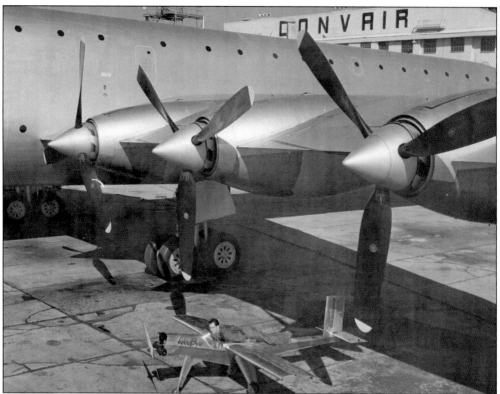

The world's largest and smallest aircraft of the time sit side by side at Lindbergh Field. The Convair XC-99 (265,000 pounds) was over 1,200 times heavier than the Wee Bee (215 pounds). Unfortunately the Wee Bee was destroyed when the San Diego Air and Space Museum burned in 1978. The XC-99 is currently being restored at Wright Patterson Air Force Base.

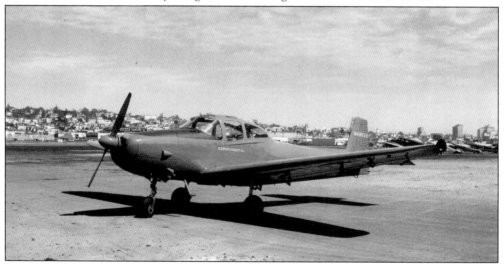

Ryan Aeronautical was another San Diego–based company to continue the development, design, and production of both civilian and military aircraft after World War II. The Ryan Navion, which was first developed by North American, is pictured here. Ryan built 1,200 of these planes before production was halted in 1951.

During the early days of the cold war, many aerospace corporations enlisted well-known Hollywood celebrities to help promote their products—Convair was no exception. Rock Hudson (center) is seen in front of a Convair TF-102 sometime in the mid-1950s. This series of aircraft was designed as a high-speed interceptor fighter. They were tasked with stopping Soviet nuclear bombers before they could get in range to launch their payload. In addition to celebrities, scantily clad women were also photographed with the aircraft.

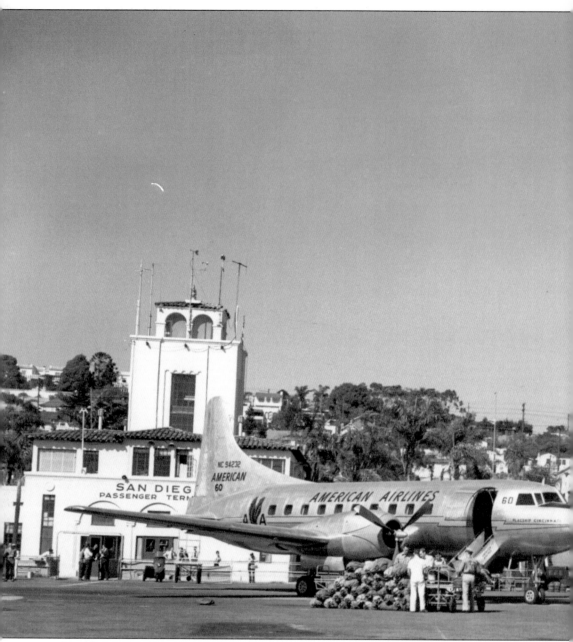

In addition to producing small civilian aircraft, Convair developed larger commercial air transports. The Convair liner model was an extremely successful postwar transport. Over 1,000 variants

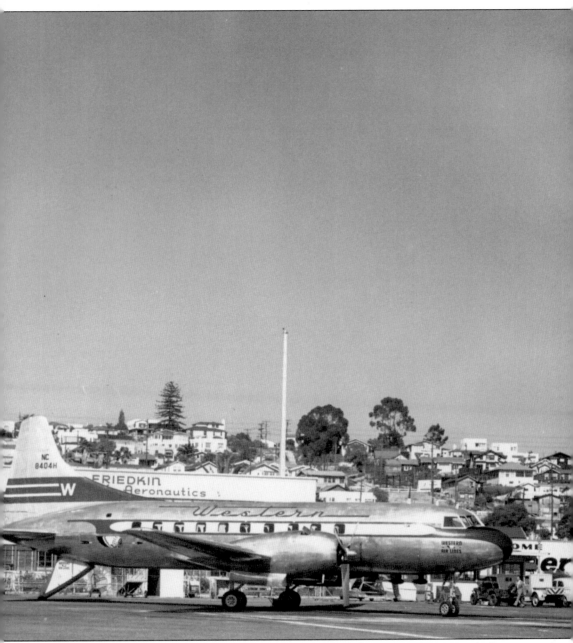

were produced. Seen here are a couple of Convair Model 240s, belonging to American Airlines and Western Airlines, at Lindbergh Field Airport.

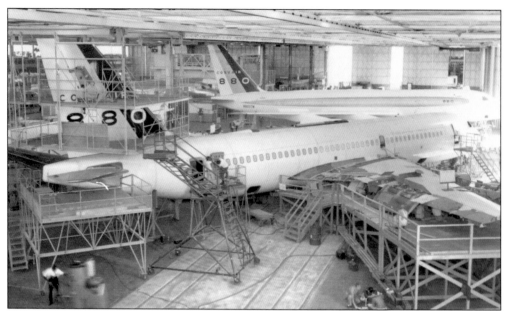

Convair also manufactured a jet-powered airliner, the 880/990 series. Seen here are two 880s under construction at Convair's Lindbergh Field facility. With a maximum cruising speed of 586 miles per hour, the 880 could carry 130 passengers. Unfortunately the 880 arrived too late on the market, unable to compete with such aircraft as the DC-8 and 707s. The 880/990 series aircraft was a financial disaster for Convair; some estimates indicate the loss to the company was close to $200 million. A Convair 880 buzzes Coronado Island as a T-33 takes chase.

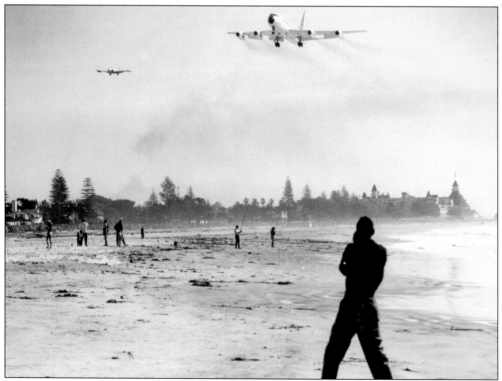

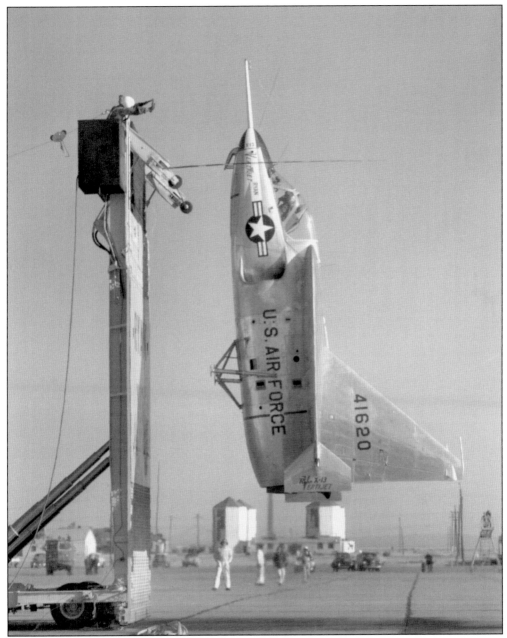

One of the most unusual designs to come out of San Diego is the Ryan Verijet. This unique aircraft was designed to take off and land vertically. It first flew in 1955. This aircraft design was successful and eventually led to better-known vertical take off aircraft like the Hawker Siddeley Harrier.

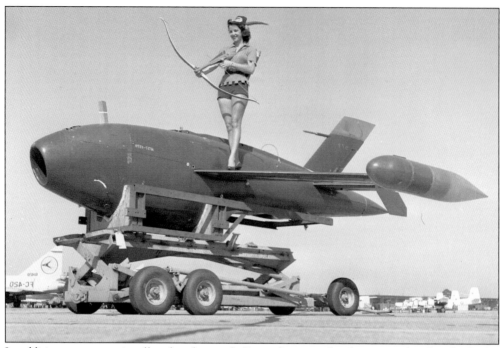

In addition to conventionally piloted aircraft, Ryan also specialized in remotely piloted vehicles used for reconnaissance and target practice. Seen here is the Ryan Firebee, a remotely piloted vehicle used in the air force air-to-air training exercise Operation William Tell. In 1999, Ryan Aeronautical was purchased by Northrop Grumman Corporation, who today continues to build very advanced reconnaissance aircraft such as the Global Hawk.

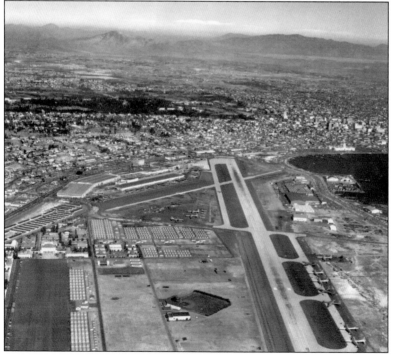

This is Lindbergh Field as it looked in 1951. The large buildings to the left of the runway belong to Convair, while the Ryan complex can be seen on the right. Note all of the large aircraft scattered around the field. These are Convair B-36s, which are being retrofitted at Lindbergh Field.

This is a view of Lindbergh Field as it was in the latter part of 1970. Terminal One can be seen left of the runway. The terminal was completed in the mid-1960s, but it was still too small to accommodate the large amount of passenger traffic. The outline for Terminal Two, which is under construction, can be seen near the top of the photograph.

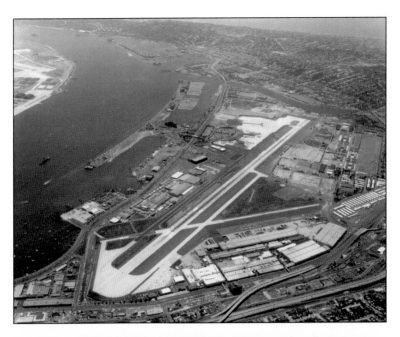

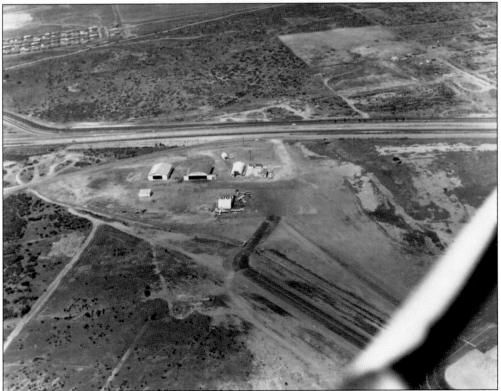

Following World War II, Lindbergh Field began to concentrate on accommodating large-scale commercial traffic. Several smaller local airports were upgraded for private pilot use. Seen here is Montgomery Field (named after John Montgomery) in the 1950s. Other airports in the area available for small aircraft operations included Brown Field and Gillespie Field.

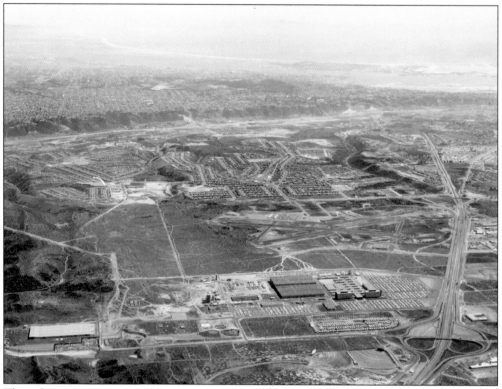

This is how Montgomery Field appeared in 1962. The large building in front of the airport is the General Dynamics Astronautics facility. Convair merged with General Dynamics in the 1950s, but the companies were not renamed, making the name issue very confusing. Many people both inside and outside the company referred to it by different names.

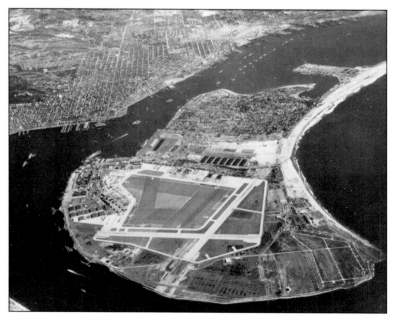

This aerial view of North Island was taken in 1947. Much has changed since the days of Glenn Curtiss. Runways, hangars, and buildings have crowded the once barren island. Even after the war, Naval Air Station North Island remained one of the focal points for military aviation in the United States.

This is an aerial view of Marine Corps Air Station Miramar. This air station originally was Army Air Base Camp Kearny. After World War II, the navy occupied and expanded the base, residing there until the U.S. Marines took over in 1997. This image was taken in 1985, the same year that the movie *Top Gun* was released, the name given to the movie's air combat school located at Miramar.

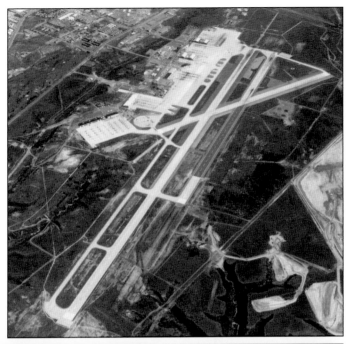

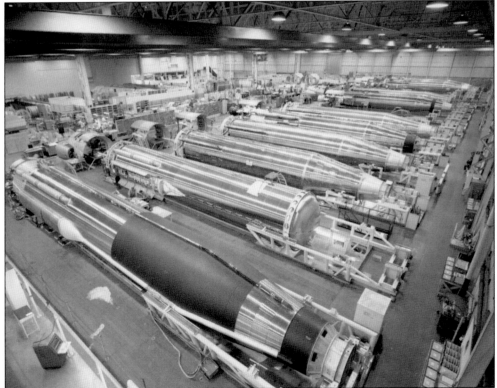

This is a rare glimpse inside the General Dynamics Astronautics facility near Montgomery Field, where production of the Atlas missiles took place. The Atlas was the first successful intercontinental ballistic missile (ICBM) able to fly up to 5,000 miles and carry a nuclear payload.

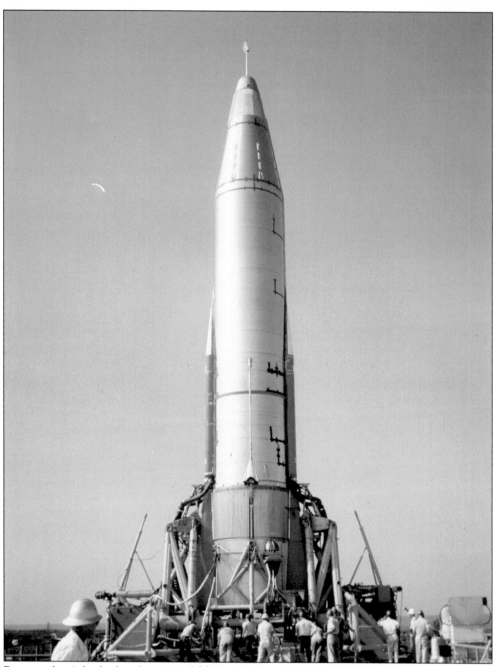

Because the Atlas had such a powerful lifting platform, it was also used by the United States in its space program. An Atlas missile launched the first Americans into orbit during the Mercury space program, which eventually led to putting a man on the moon.

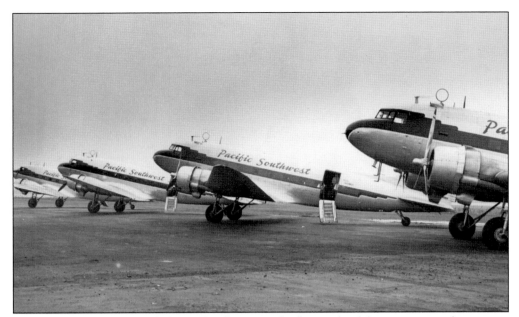

Soon after World War II ended, Ken Friedkin started a flying school, but it was not as lucrative as he had hoped. In 1949, he founded Pacific Southwest Airlines (PSA), providing passenger flight service from San Diego to Oakland using DC-3 aircraft. The company grew quickly because of its friendly service and low airfares. Seen here is a lineup of the PSA DC-3s at Lindbergh Field. Inexpensive airfares, at prices such as $21.84, is the reason PSA got the nickname "Poor Sailors Airline."

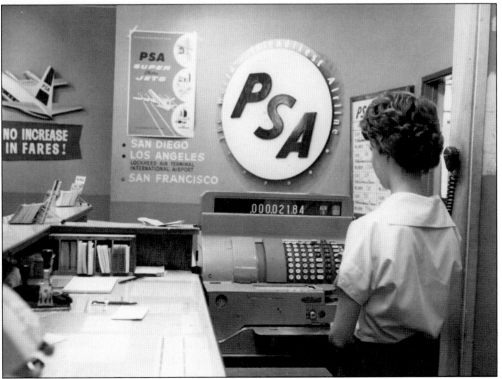

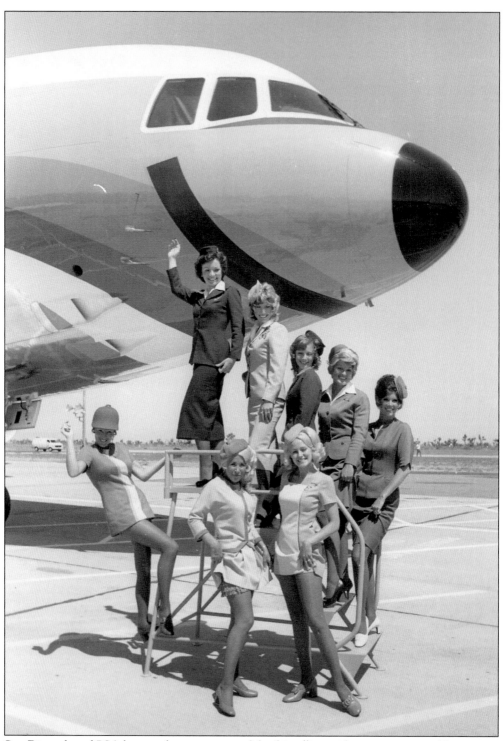

San Diego–based PSA became known as one of the friendliest airlines in existence. To assist in promoting this reputation, a smile was painted on the front of the airline's passenger fleet. Here PSA flight attendants pose in front of PSA's Lockheed L-1011.

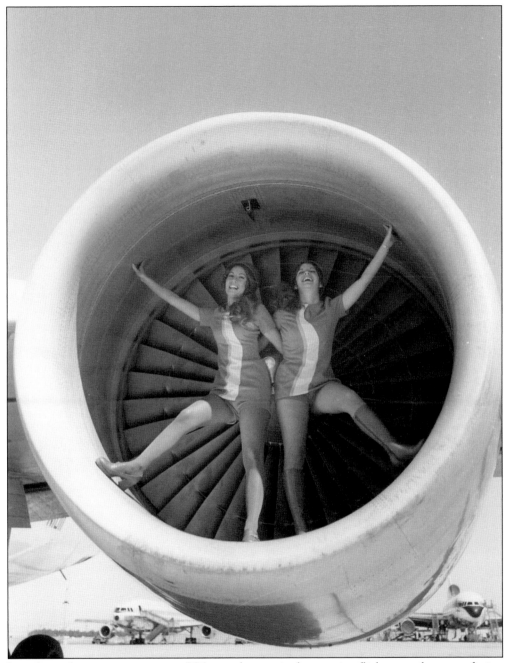

In order to lure more passengers, PSA openly recruited attractive flight attendants, outfitting them in uniforms illustrating the latest fashion. Many times these uniforms were very small and showed a lot of skin. Seen here are two flight attendants standing in the engine intake of a Lockheed L-1011.

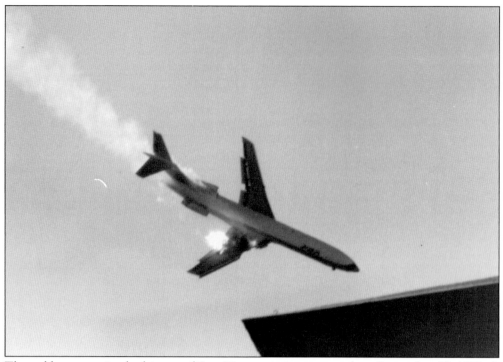

The saddest event in the history of San Diego aviation occurred on September 25, 1978. A PSA-owned Boeing 727 airliner collided with a privately owned Cessna 172 over San Diego. All 135 passengers onboard the 727 were killed, along with the two men aboard the Cessna. In addition, seven people on the ground, including a family of four, were killed. Nine others on the ground were injured and 22 homes were destroyed or damaged. This aircraft disaster is the worst in California to date.

In the 1960s, a group of San Diego residents decided that a museum was necessary to commemorate the area's unique aviation heritage. Recruiting many volunteers and working diligently, the San Diego Aerospace Museum became one of the preeminent flight museums in the world by 1978.

On February 22, 1978, a fire set by an arsonist almost completely destroyed the San Diego Aerospace Museum. Many extremely rare airplanes, with ties to local history, were lost in this fire, including a *Spirit of St. Louis* replica, numerous Ryan aircraft, a Hall flying car, and a Wee Bee.

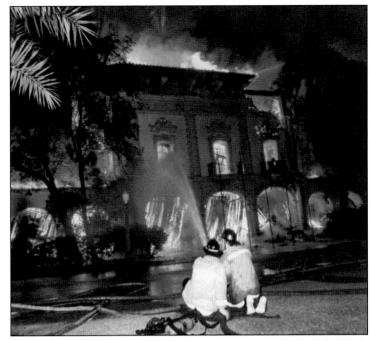

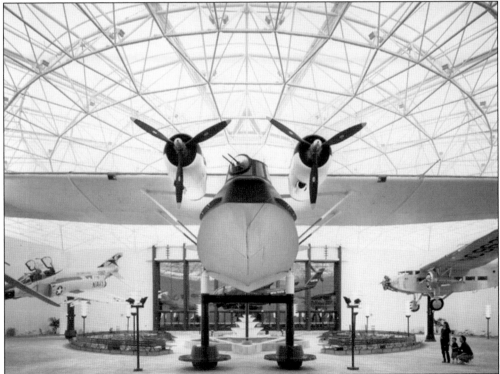

After the fire, the local community rallied to reestablish this prestigious aerospace museum. Just a few years after the devastating fire, the museum reopened in the historic Ford Building in Balboa Park. Today the renamed San Diego Air and Space Museum is once again rated among the best in the world.

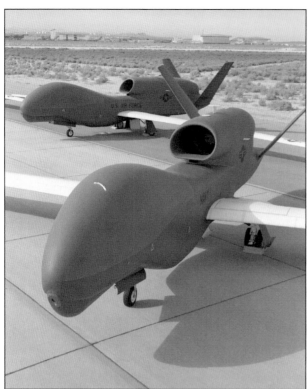

As the new millennium dawned, Ryan and Convair/General Dynamics vacated their giant Lindbergh Field manufacturing plants, but the local aerospace industry is still going strong. In 1999, Ryan Aeronautical was purchased by Northrop Grumman and relocated to a facility in Rancho Bernardo. Pictured here is the Ryan-designed RQ-4 Global Hawk, currently in production by prime contractor Northrop Grumman.

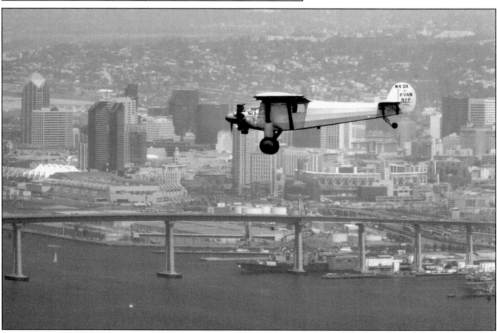

Did Charles Lindbergh get caught in a time vortex? No, this is the San Diego Air and Space Museum's *Spirit of St. Louis* replica flying over San Diego in August 2003 to commemorate the 75th anniversary of Lindbergh Field. This aircraft was built to replace the replica lost during the museum fire of 1978.

The Everett-based USS *Lincoln* led the way in responding to requests for humanitarian aid after the devastating tsunami on December 26, 2004, in Banda Aceh, Indonesia. The tsunami destroyed more than 75 percent of coastal bridges and 25 percent of coastal roadways, making many villages and refugee camps accessible only by rotary-wing aircraft. Within five days of the disaster, U.S. Navy helicopters from San Diego attached to the Lincoln Strike Group established relief operations. A *Lincoln*-based helicopter is seen here delivering much needed water and food to displaced villagers.

San Diego–based aircraft have contributed to numerous humanitarian efforts around the world as well as in the United States. An SH-60B Seahawk helicopter assigned to Helicopter Anti-Submarine Squadron Light Four Nine (HSL-49) takes off from NAS North Island to support search-and-rescue missions in the aftermath of Hurricane Katrina.

Seen here is a pilot from the "Battle Cats" of HSL-43 checking the rotor head of an SH-60F Seahawk assigned to the "Wolfpack" of HSL-45 during a preflight inspection.

In addition to humanitarian efforts, aircraft throughout San Diego County, including Miramar, Camp Pendleton, and North Island, have deployed to the Middle East and Afghanistan in support of the global war on terrorism. The Nimitz-class aircraft carrier USS *Ronald Reagan* is seen leaving San Diego Bay in January 2007. The *Ronald Reagan* is en route to the Middle East.

Today NAS North Island is still considered one of the major military facilities in the United States. The USS *Ronald Reagan* and the USS *Nimitz* are among the ships currently homeported in San Diego. There are also numerous aircraft assigned to this base, many of which are tasked with homeland security missions.

BIBLIOGRAPHY

Bowers, Peter M. *Curtiss Aircraft 1907–1947*. London: Putnam, 1987.

Casey, Louis S. *Curtiss, The Hammondsport Era 1907–1915*. New York: Crown Publishers Inc., 1981.

Scott, Mary L. *San Diego Air Capital of the West*. Virginia Beach, VA: The Donning Company Publishers, 2005.

Sudsbury, Elretta. *Jack Rabbits to Jets: the history of NAS North Island, San Diego, California*. San Diego: San Diego Publishing Company, 1992.

Van Deurs, George. *Anchors in the Sky: Spuds Ellyson the First Naval Aviator*. San Rafael, CA: Presidio Press, 1978.

Wagner, Ray. *The History of U.S. Naval Airpower*. New York: Military Press (distributed by Crown), 1985.

Wagner, William. Reuben *Fleet and the Story of Consolidated Aircraft*. Fallbrook, CA: Aero Publishers, Inc. 1976.

———. *Ryan the Aviator: Being the Adventures and Ventures of Pioneer Airman & Businessman T. Claude Ryan*. New York: McGraw-Hill, 1971.

Wegg, John. *General Dynamics Aircraft and their Predecessors*. Maryland: Naval Institute Press, 1990.

DISCOVER THOUSANDS OF LOCAL HISTORY BOOKS
FEATURING MILLIONS OF VINTAGE IMAGES

Arcadia Publishing, the leading local history publisher in the United States, is committed to making history accessible and meaningful through publishing books that celebrate and preserve the heritage of America's people and places.

Find more books like this at
www.arcadiapublishing.com

Search for your hometown history, your old stomping grounds, and even your favorite sports team.